IMAGES
of America

SANIBEL ISLAND

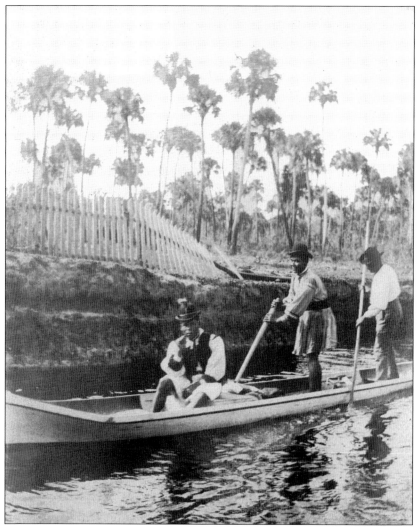

This photograph, taken c. 1890–1910, shows three Seminole Indians using poles to canoe on the Caloosahatchee River en route to Fort Myers for supplies. The Seminoles were an inland tribe of Creek descendants and escaped slaves. Some of the Calusa Indians, original inhabitants of Sanibel, joined the Seminoles after they were driven from the island by Spanish explorers. (Courtesy Sanibel Public Library and the Sanibel Historical Museum and Village, made available by the Southwest Florida Library Network [www.swfln.org] and the Publication of Archival, Library, and Museum Materials [palmm.fcla.edu/].)

ON THE COVER: According to the Sanibel Historical Marker placed on the lighthouse property in 1974, the first English-speaking settlers arrived on Sanibel in 1833 from New York. Although that settlement was short lived, the initial colonists petitioned the United States government for a lighthouse to be constructed on the island. No action was taken on that proposal at the time. By the late 1870s, seagoing commerce in the area had increased in volume. The U.S. Lighthouse Bureau took the initiative in requesting funds for a lighthouse for Sanibel Island, and in 1884, construction of the tower began. The station was lit for the first time in August 1884. The significance of the Sanibel Lighthouse lies in the regular and reliable service it has provided for travelers along Florida's west coast. (Courtesy Southwest Florida Museum of History.)

IMAGES
of America

SANIBEL ISLAND

Yvonne Hill and Marguerite Jordan
in collaboration with the
Lee County Black History Society, Inc.

ARCADIA
PUBLISHING

Published by Arcadia Publishing
Charleston, South Carolina

Printed in the United States of America

Library of Congress Catalog Card Number: 2007938603

For all general information contact Arcadia Publishing at:
Telephone 843-853-2070
Fax 843-853-0044
E-mail sales@arcadiapublishing.com
For customer service and orders:
Toll-Free 1-888-313-2665

Visit us on the Internet at www.arcadiapublishing.com

This book is dedicated in loving memory to Isaiah and Hannah Gavin, Harry and Pearl Alice Walker, Edmond and Elnora Gavin, James Carl and Mozella Jordan, and to all islanders who have helped to foster this uniquely cohesive and environmentally conscious community. Most notably, this community has an origin that is ethnically, economically, and socially as diverse as the animal and plant life it supports.

Although many of these people have departed, their legacies and contributions continue to live on and shine like the lighthouse beacon, reflecting their character, pride, and perseverance during happy and adverse times. Their values continue to guide us today. Let us always be mindful of our duty to be good, responsible stewards of the legacies they left behind and set similar examples for our children.

Contents

ACKNOWLEDGMENTS

This book would not have been possible without the help of many individuals and organizations. We would especially like to thank the following: Ali Lumumba, Lee County Black History Society, Inc.; Chris Jones, Southwest Florida Library Network; Candance Heise, Sanibel Public Library; Margaret Mohundro, Sanibel Public Library; Betty Anholt, Sanibel Public Library; Francis Bailey; Sam Bailey; Francine Litofsky; Alexander Werner and Dennis Simon, Sanibel Historical Museum and Village, Inc; Peggy Ford, Island Inn; Jim Jordan; Eugene Gavin; Oscar Gavin; Judge Dickson; Charlie McCollough; Mary Irving; Victor Zarick; Ann Bradley, Captiva Public Library; Sanibel Historical Museum and Village; Williams Academy Black History Museum; Southwest Florida Museum of History; Luke Cunningham; Kate Crawford; and FedEx/Kinkos.

Unless otherwise noted, all photographs are courtesy of the Sanibel Public Library and the Sanibel Historical Museum and Village, made available by the Southwest Florida Library Network (www.swfln.org) and the Publication of Archival, Library, and Museum Materials (palmm.fcla.edu/).

INTRODUCTION

Sanibel Island is a barrier island located off the west coast of Florida and surrounded by the Gulf of Mexico.

In earlier and simpler times, living on Sanibel meant a life of sacrifice and hard work. The island's early settlers and pioneers came from different walks of life. They were laborers, fishermen, farmers, shopkeepers, hoteliers, doctors, teachers, preachers, cooks, adventurers, artists, and writers, just to name a few. There were those who possessed very striking character and compelling personality traits among many other talents. It is because of these people that Sanibel has developed into the place it is today, a sanctuary island where people and wildlife live in harmony together.

Since the early 1960s, many visitors have come to this island to live, work, or to enjoy an unfettered lifestyle. As the winds of change swept across the country during the 1960s, the values deeply rooted in the Sanibel community enabled it to grow and prosper in the spirit reflective of national ideals about human dignity and equality.

Sanibel was originally settled by the Calusa Indians. Although there is some speculation about its name, it is generally conceived that Sanibel Island was named "Santa Isybella" in honor of Queen Isabella by Juan Ponce de Leon in the early 1500s.

American settlers began arriving in the 1800s. These pioneers were comprised of both white and black individuals that migrated to Sanibel when the island was still virtually a wilderness. The rich, fertile soil on the island was perfectly suited for agriculture, and originally farming was the main industry, with crops of tomatoes, peppers, coconuts, and citrus fruit. The prospect of sharecropping and farming on Sanibel Island was inviting to young and eager families searching for a safe and productive place to settle and raise their growing families.

With the promise of Sanibel's rich and productive soil for farming, this was the place to be. It remained that way until the hurricane of 1926. With that horrendous storm, seawater covered the island from gulf to bay, polluting the soil. The island soil, after having renourished itself following the hurricane of 1921, was unable to recover from this new devastation. This natural disaster was the final blow to the farming industry and to the flourishing fields of the hardworking sharecroppers. The soil would remain that way, unfit for planting or farming, for many, many years to come. Still the families stayed and persevered. In time, with much hard work and endurance, ingenuity, and resourcefulness, the early settlers found alternative ways to make a living while fighting unbearable heat and horrendous swarms of mosquitoes that blackened windows and doors, making day appear as night.

Eventually the lure of beautiful white beaches attracted a small tourism industry. Bed and breakfasts became a booming industry. Sanibel became the third greatest shelling area in the world, which led to an increase in tourism. The hurricanes of 1921 and 1926 had destroyed the viability of the land for farming, but the tourism industry continued to grow. Today Sanibel Island's main industry is tourism.

Those people familiar with Sanibel Island often think of pristine beaches, wildlife, and shells. Too few know about the other riches, the historical offerings of this barrier island. This publication will attempt to capture the diverse legacies hidden here on Sanibel.

One

EARLY SETTLERS

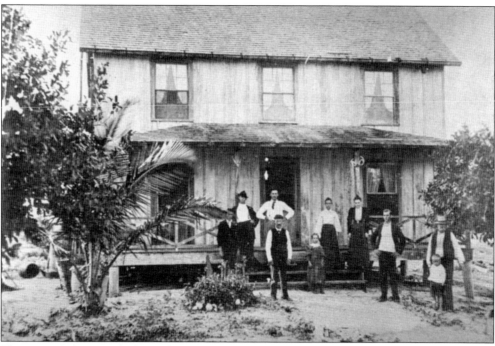

This *c.* 1895 photograph shows the Woodring family and friends at the Woodring homestead on Woodring Point shortly after homesteading on Sanibel. The house was built with lumber from Key West. Originally from Pennsylvania, the Woodrings came to the area when Sam Woodring Sr. answered an advertisement for an ironworker at the San Carlos Hotel on nearby Pine Island. Woodring became familiar with Sanibel while serving in the Civil War and moved to the island shortly after the area was declared officially open for homesteading in 1888. Generations of Woodrings became fishing guides on Sanibel, and Woodring descendants still live at the original homestead site. After Woodring's death in 1899, his widow, Anna, offered lodging for visitors. Posing from left to right are Mr. Gooddell, George Underhill, Allie Collins, Carl Woodring, Flora Woodring, Anna Woodring, Annie Woodring, Sam Woodring Jr., Sam Woodring Sr., and Harrison Woodring.

Will Matthews (pictured c. 1920), his wife Hattie, and four young children came to Sanibel in 1895. The Matthewses heard about Sanibel Island from a former Kentucky native, Rev. George O. Barnes. Life in Kentucky was not easy after the Civil War, and jobs were scarce. Matthews, an accountant by profession, planned to change careers and become a truck farmer on the beautiful island paradise with fertile soil. Too late to take advantage of the Homesteading Act of 1888, Matthews started farming on a homesteader's property, growing winter tomatoes. He met with little success, and eventually the farming venture failed because of his inexperience. (Courtesy Francis Bailey.)

Harry Bailey sits in the Bailey house on Periwinkle Way in Sanibel during the early part of the century. Harry settled in Sanibel with his mother and two brothers, Frank and Ernest Bailey, in 1888. The brothers all farmed. The island population was only 200 people, and it was not long before the Matthews and Bailey families became fast friends. Frank, a shrewd farmer and merchant, took over the Matthewses' bayside dock and warehouse in 1899, growing it into a moneymaking venture. He and his brothers started the Sanibel Packing Company, which packed and loaded island produce onto river steamers. The packing company was also the island's only store and evolved into the Bailey general store. The hurricane of 1926 wiped out the packing company, and the Baileys rebuilt a larger store in a more secure location. (Courtesy Francis Bailey.)

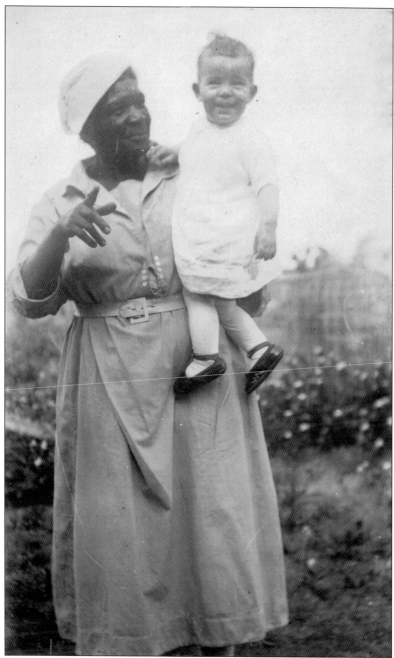

Frank Bailey became a leading figure on Sanibel. He raised three sons on the island. In the above 1920s picture, his oldest, son Francis Bailey Jr., is shown as a baby in the arms of his favorite nanny. Francis Jr. was about six months old when this photograph was taken. While her full name escapes him, Bailey vaguely remembers calling her "Aunt Hattie." He recalls many fond memories of time spent with Hattie on the family's Sanibel farm. It is not known where Hattie came from, but it is quite possible that she traveled to Sanibel with the family of Frank Bailey Sr. His mother arrived with three small sons and, as was sometimes the practice during that time period, a nanny raised more than one generation in the same family. (Courtesy Francis Bailey.)

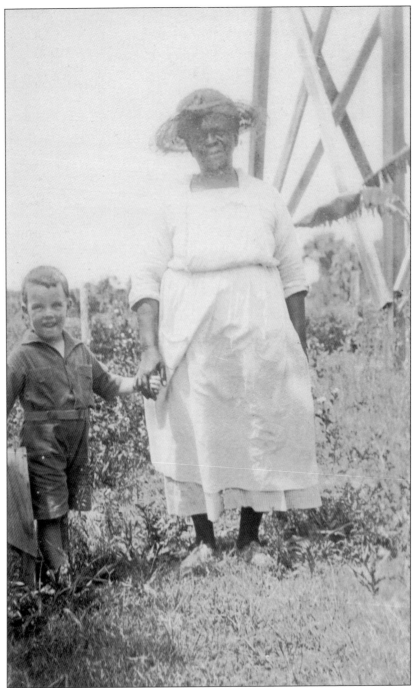

This photograph shows Francis Bailey Jr. with a woman who may have been named Arsenia on the right, one of the domestic servants on the family farm. This picture may have been taken on a Sunday, since Francis appears to be dressed for a special occasion and Arsenia is wearing a somewhat fancy hat. Arsenia, along with other Bailey household help had to be let go during the Depression in the 1930s. Francis Bailey remembers the pain he felt and the tears he cried when the servants left. (Courtesy Francis Bailey.)

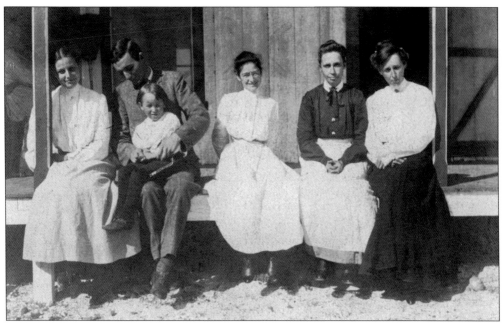

In this photograph *c.* 1890–1910, the Sears family poses, possibly on the porch of the Matthews Hotel, later known as the Island Inn. Isabel Sears, in white, is in the center of the photograph. The Sears family frequently visited to the island. On one such visit, the family stayed on their houseboat in Tarpon Bay. The picture below shows the Sears family waiting for a train in front of the Southern Express Company office at the beginning of the 20th century. Several generations of Sears have settled on the island.

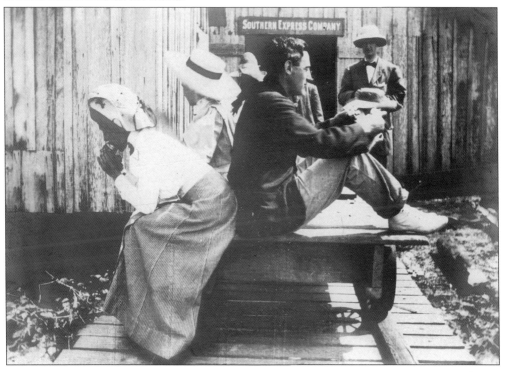

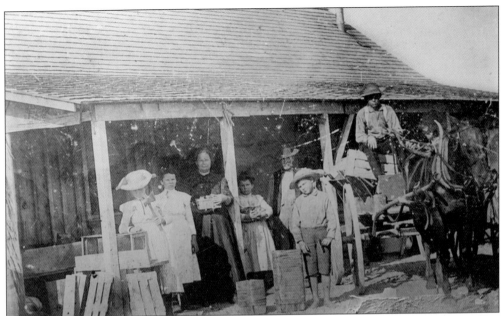

This photograph shows the Gibson family in their packinghouse in the early 1900s at Wulfert Point. The family planted, picked, packed, built boxes, and hauled their produce to the dock for the steamers to pick up. The Gibsons arrived on Sanibel in 1900, first working for farm partners Dwight and Holloway before going to work for themselves. There were several packinghouses located on the island, as farming was the main industry.

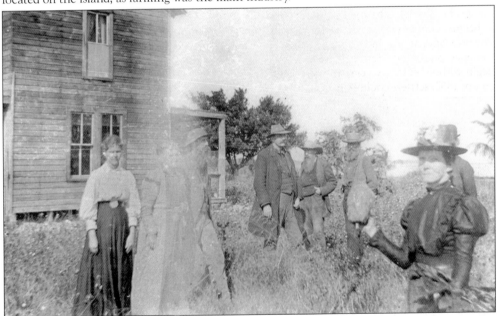

In this c. 1905 photograph, neighbors gather beside the Thomas Holloway house on Wulfert Point in Sanibel. Included in the photograph from left to right are four unidentified individuals, Captain Duffy, another unidentified person, and Jennie Doane in the foreground. The Holloway and Doane families came to Sanibel around 1897. Doane was an independent thinker for a woman of this era and often took unpopular stands on issues like women's rights.

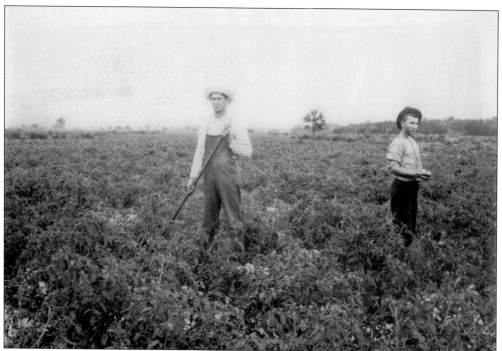

On January 1912, Stark Sanford Carraway and Belton C. Johnson pose for this picture in a Sanibel tomato field. The tomatoes were grown primarily for export and were a big moneymaking crop on Sanibel until the hurricane of 1926. After this natural disaster, tomato and other crops failed to grow because of saltwater intrusion of the once-fertile soil. The Carraways farmed at Wulfert, a thriving community at the north end of Sanibel. Belton Johnson's family farmed near Tarpon Bay on island, and he later became a preeminent fishing guide. In the *c.* 1908 photograph below, the open prairie of interior Sanibel is obvious. Vast expanses of open land allowed farming to begin without extensive clearing of vegetation. With the enactment of the Federal Homestead Act of 1862, settlers could homestead 160 acres of land.

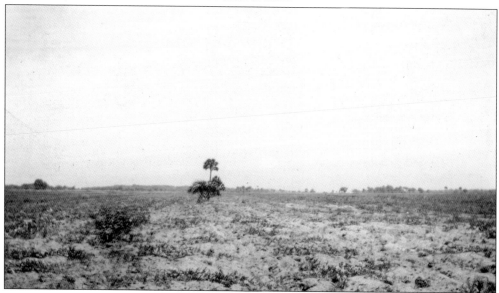

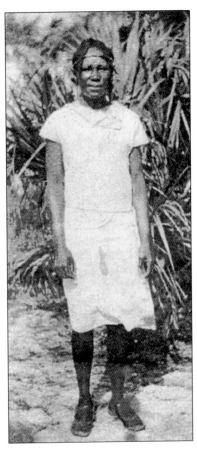

Hannah Gavin, pictured at left, and her husband, Isaiah Gavin, came to Sanibel in the early 1900s from Walkulla County, near Tallahassee, with their four children. The Gavins originally came to Sanibel to sharecrop on the island's rich and fertile soil and were the first black family to establish residency on Sanibel in 1917. When the hurricane of 1926 ruined the farming industry, Isaiah found another way to make a living and became known for his landscaping expertise. He is credited with planting the pine trees that lined Periwinkle Way, Sanibel's main road at the time. Any tree on this thoroughfare not directly planted by Gavin grew from a seed off one of his trees. The photograph below shows Isaiah Gavin on the right with his son Oscar Gavin. (Courtesy Oscar Gavin.)

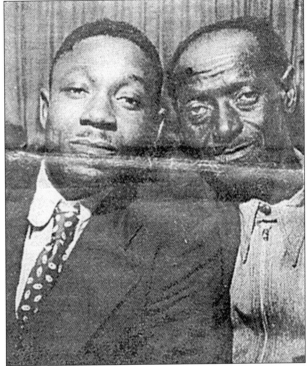

The portrait at right is of Oliver Bowen, an early homesteader on Sanibel Island. He was a former Mississippi River boat pilot and Confederate navy pilot. Bowen knew Mark Twain (Samuel Clemens), and his adventures were often a source of material for the author. Bowen and his family migrated to Sanibel from Trinidad in the late 1880s. Bowen experimented with plants, including agave brought from South America to Sanibel. He conferred with Thomas Edison on his agave research, but there is no record of any conclusive discoveries or collaborations. Below is a picture of the barn from the homestead of Oliver Bowen's family on Wulfert Road. Bowen brought much of the material for his buildings, including slate roof tiles, from Trinidad, where he had been living the previous decade.

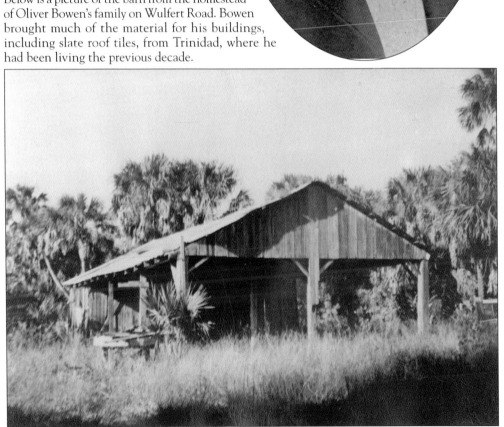

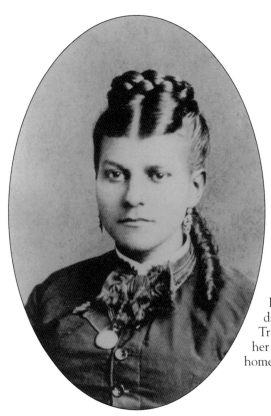

Mary de Santos Bowen, wife of Oliver Fellows Bowen, married Oliver in Trinidad in 1878. She was a native of the Azores, born in 1844, and migrated with her parents to Trinidad as a child. Mary kept the homestead going while an eccentric Oliver experimented with his plants. Their third child, Albert Marvin, was born in 1890 on Sanibel. Mary returned to Trinidad after her husband's death. Marguerite Emily Bowen, in the photograph below, was the daughter of Mary and Oliver. She was born in Trinidad in 1882 and migrated to Sanibel with her family when they came to the island as early homesteaders on Wulfert Road.

An older Oliver Bowen, pictured at right, was born in 1828 and died in 1894 on Sanibel. At Bowen's request, his wife, Mary, buried him in his well at the family homestead on Wulfert. Shown below is the gravestone of Oliver Fellows Bowen. Bowen was a hero to Samuel Clemens (Mark Twain). In later years, Oliver moved to Sanibel with his Trinidadian wife, Mary de Santos, and raised their children on the island.

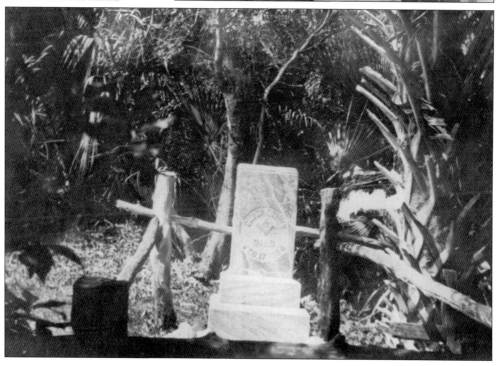

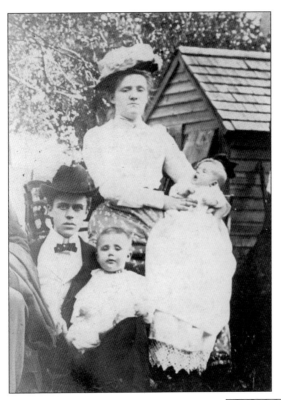

The family of Walter A. Skinner is shown in the September 1902 photograph at left from the album of Jennie Doane. The Skinners were probably good friends or neighbors of Lewis and Jennie Doane. The family portrait appears to have been taken at a location on Wulfert Point.

In this photograph, taken in January 1904, Lewis and Jennie Doane look over their Wulfert garden. Jennie Doane was very active in the growing community of Wulfert. Among other things, she served as the postmistress of the Wulfert post office. The high fence visible in the background was probably to protect the garden from deer, which often ravaged crops on the island in the early years of the century.

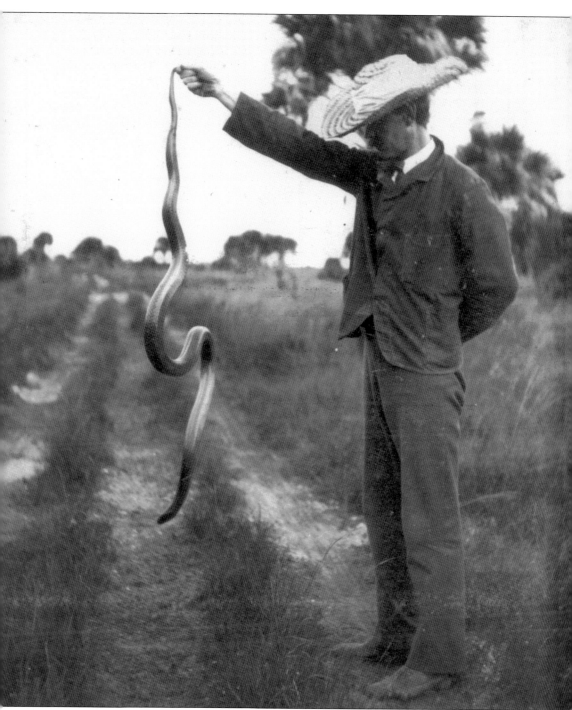

Will Barnes shows off a large yellow rat snake found crossing the prairie path near the Sisters Hotel owned by his father. William C. Barnes was the son of Rev. George Barnes, one of the original homesteaders, who came to Sanibel from Kentucky in 1889. Yellow rat snakes are greenish, yellow, or orange, with four dark stripes running the length of the body. This type of snake is often found along the coastline in southeastern states.

Pearl Alice Walker, wife of Harry Walker Sr., moved to Sanibel from Freeman Grove, Georgia, in the early 1920s. Pearl Alice and Harry Sr. were the second black family to settle and sharecrop on Sanibel, preceded by the Gavins in 1917. Pearl Alice and her husband raised all of their children on Sanibel. She worked as a domestic while raising her children and caring for the homestead. One day in 1949, Harry and Pearl Alice returned from mainland by the ferryboat to find that someone had set fire to their island home. All that remained was a handful of glowing embers. With the help of their brother-in-law, Isaiah Gavin, they relocated to a home on Tarpon Bay Road. Pearl Alice remained in that home until the late 1970s. (Courtesy Jim Jordan.)

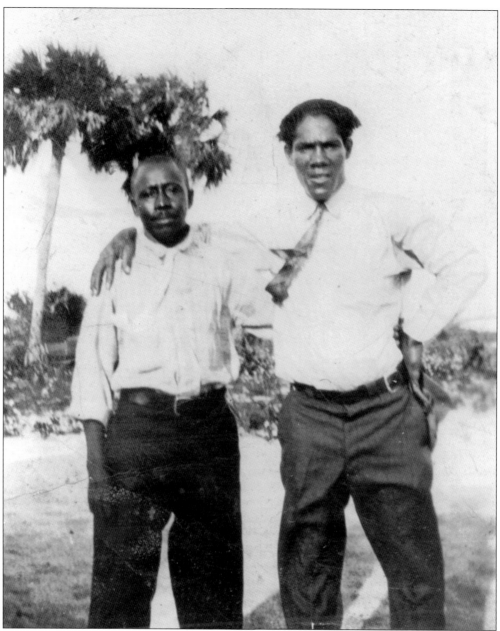

In the above photograph, Harry Walker Sr. stands on the left with his friend Charles Minyard. The Walkers arrived on Sanibel to sharecrop in the 1920s. After the devastating hurricane of 1926, farming was no longer an option because seawater had covered the island from gulf to bay, sinking into the soil. This natural disaster served as the final blow to the farming industry, which would remain unfit for planting or farming for many years to come. Harry Sr., faced with the reality of supporting his growing family, found work as a laborer, which he continued to do until farming was once again a viable option. His gardens always yielded a bounty of delicious fruits and vegetables. The date palm trees and the sapodilla trees planted around their home were always loaded with fruit. Harry Walker remained an industrious farmer on the island until his death in 1969.

The portrait above shows Isaac J. Johnson, brother-in-law of Harry Walker Sr., who sharecropped on Sanibel in the 1920s. Johnson arrived on the island from Lake Placid in 1922. He worked in the citrus groves with his own team of horses and his two oldest sons. He decided to start farming for himself and traveled to Sanibel on the advice of a family who suggested that Fort Myers was the best place for his children to receive an education. Johnson homesteaded on property located off Tarpon Bay and Island Inn Road. While farming on Sanibel, Johnson accumulated his own truck, tractor, horses, mules, and cultivators, which enabled him to be self-sufficient. Committed to religion and education, Johnson was instrumental in establishing the first black school on Sanibel in 1927. He donated an old Baptist church located on his property for use as the school. The building also served as a place of worship for the black families on Sanibel, as well as a gathering place for black community celebrations. (Courtesy Lee County Black History Society, Inc.)

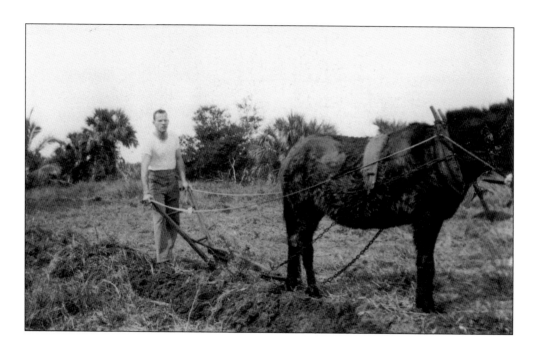

The picture above, taken in December 1947, is of Francis Bailey Jr. with his mule-drawn plow working the fields on the Baileys' Sanibel Island farm. Bailey, the son of Frank Sr., not only worked on the family farm but also assisted his father with the family business, the Sanibel Packing Company and General Store. The photograph below, taken in the early 1900s, shows Sanibel as just a prairie land when transportation was mainly by mule or horse-drawn buggies or carriages. Mules were used more often because they were better suited to work in the intense heat and mosquito-infested conditions.

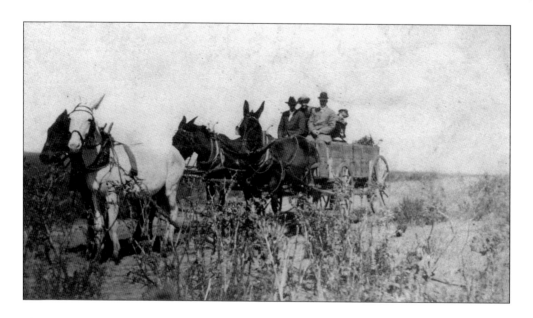

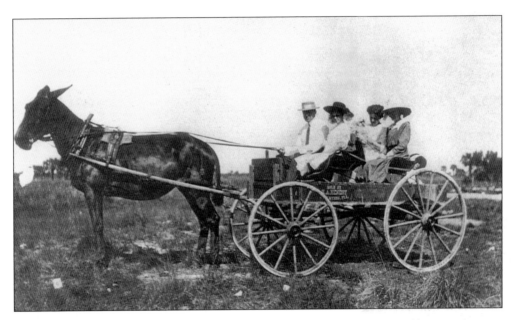

This early view from around 1908 of the empty Sanibel prairie shows a typical horse and wagon used to take visitors from the bayside steamboat to the Sisters Hotel, later known as the Casa Ybel. In the photograph above, Alice Tayntor is at the far right in the buggy. The Tayntor family was common winter residents to Sanibel, staying at the Sisters Hotel in the same cottage every season. Alice's father, Charles Tayntor Sr., was a member of the U.S. Olympic shooting team who practiced his shooting skills while vacationing on the Sanibel beaches.

The Gavins are shown using the common form of transportation, mule and buggy, to haul and sell their vegetables in the early 1920s. The Gavin family began homesteading and farming in 1917 with their father, Isaiah. Island farmers found success growing predominantly tomatoes and limes. They also had success growing cucumbers, eggplants, watermelons, radishes, and bananas. Sanibel had a nine-month growing season, from October through June. During the summer months especially, the heat of the sun, mosquitoes, and no-see-ums all combined to make the farmhands miserable. The Gavins endured and remained successful farmers until later years, when their resourcefulness led to other professions. Oscar Gavin, brother of Isaiah, started the first rubbish removal business on Sanibel in the early 1950s, using his truck for hauling garbage over to the mainland. For the industrious Gavin brothers, necessity was indeed the mother of invention.

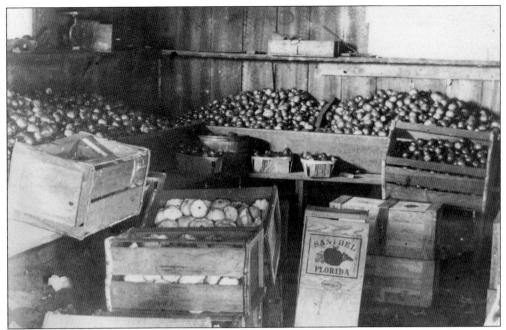

Early Sanibel sharecroppers raised tomatoes, peppers, cabbage, and lima beans. Sanibel tomatoes were considered a delicacy and were in great demand from coast to coast, which added to the prosperity of the farming community. The picture above shows an early packinghouse in 1911. Steamers arrived every morning, examiners inspected the produce, and deals were made.

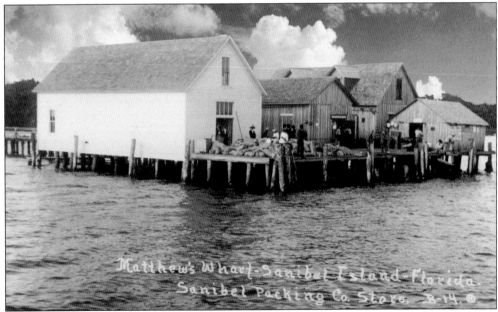

Matthew Wharf, the Sanibel Packing Company's store, was the main shipping point on and off Sanibel. Now island farmers could actually sell their crops nationwide. Soon Sanibel tomatoes were everywhere. They were particularly sought after in popular New York grocery stores. The packing company and wharf above were destroyed in the 1926 hurricane. The new store was rebuilt on land instead of on the bay. (Courtesy Francis Bailey.)

Francis Bailey Sr. arrived on Sanibel in 1894 by steamboat. He eventually farmed as much as 600 acres on Sanibel Island. He founded the Bailey general store with his brothers, Ernest and Harry. He died in 1952 and left his three sons, Francis Jr., Sam, and John, to run the family business. The picture below shows Francis, Sam, and John Bailey on their family's Sanibel Island farm. The brothers learned the family business at an early age and worked diligently together on the family farm and in the general store to carry on the tradition set by their father. (Courtesy Sanibel Historical Museum and Village, Inc.)

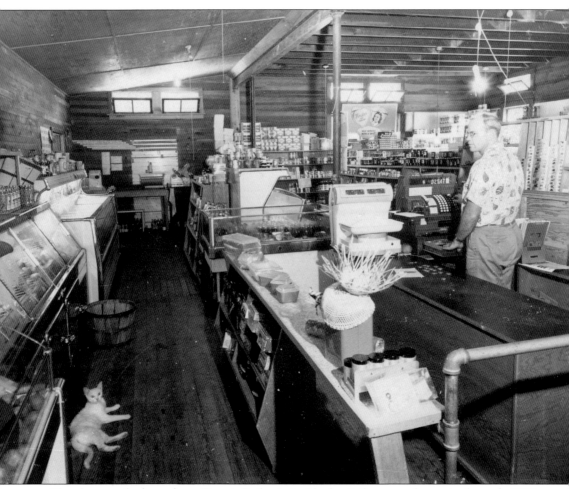

The photograph above shows Francis Bailey Jr. inside the Bailey general store in the early 1950s. Francis Bailey Sr. ran and operated the first family store on Sanibel. The Bailey general store sold a variety of items—everything from shoes, clothing, and food to gasoline. Their motto was, "If we don't have it, you don't need it." The store also served as a local community gathering spot where people came to get the current news and weather reports, pick up mail, and buy tobacco. It was the local Western Union station, and Bailey Sr. also served as the local justice of the peace. (Courtesy Sanibel Historical Museum and Village, Inc.)

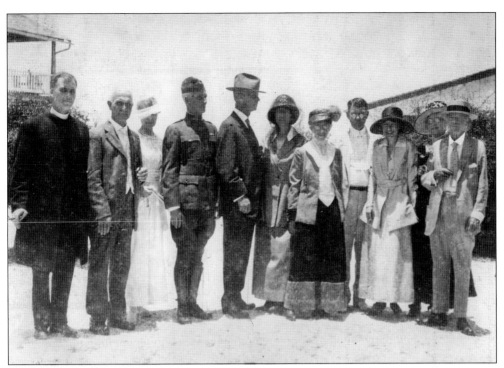

Frank Bailey and Annie Meade Matthews are pictured on their wedding day at the Matthews Hotel on January 19, 1919. From left to right are Reverend Shore, Harry and Miriam Bailey, Ernest Bailey, Frank and Annie Bailey, Hallie and Will Matthews, Charlotta Matthews, Alice Bailey Garvey, and husband Will. At right, the loving couple is pictured on their wedding day on the beach in front of the Matthews Hotel. In 1935, Annie Meade Bailey, mother of the couple's three teenage sons, Francis, John, and Sam, died at age 48.

Mr. Wilson was a farmer. He came to Sanibel in the early 1920s to improve his health with the warm climate, sunshine, and tropical breezes. It was said by many that his tomatoes were the best and sweetest ever eaten. His daughter, Stella Belle Wilson, was a schoolteacher on Sanibel.

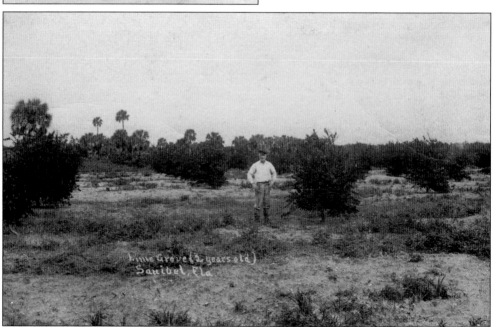

Harry Bailey stands in his two-year-old lime groves on Sanibel in the early part of the century. Brothers Harry, Frank, and Ernest Bailey all worked at farming and ran the Sanibel Packing Company and Bailey general store on Sanibel. Harry later moved to Fort Myers and left the store and packing company operation to his brothers.

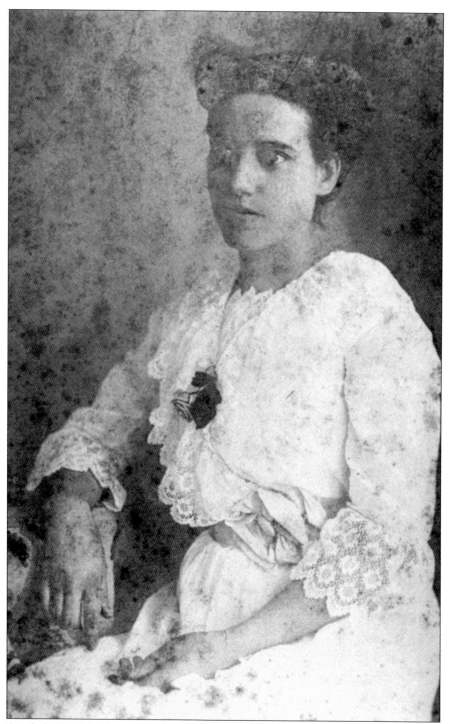

Flora Sanibel Woodring Morris is thought to be the first non-Native American child born on Sanibel. She was the daughter of homesteaders Sam and Anna Woodring of Woodring Point. In 1911, she married John Morris, later a Lee County commissioner. Morris grew and cultivated many new varieties of mangoes in the Iona area. This picture was taken around 1910.

Sam Woodring Jr. sits on the porch of his Sanibel home in this picture around 1920. Sam was the son of early settlers Sam Woodring Sr. and Anna. Woodring Sr. became acquainted with this area while serving in the Civil War. In the photograph below, Sam Woodring Jr. (on horse) and Eldon "Dad" White confer at Woodring Point in the 1930s. White was a handyman at the point on Sanibel's north shore. Woodring Jr. was a well-known fishing guide on Sanibel. He was also the major supplier of bootlegged spirits during Prohibition and a generous supporter of many local projects.

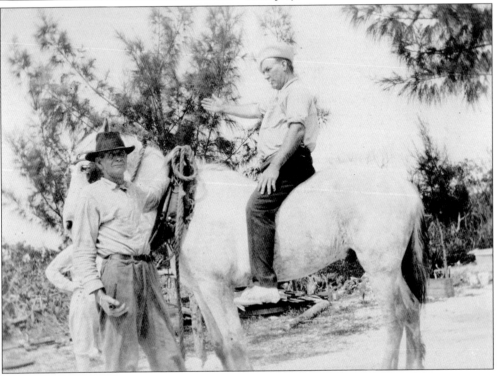

Peter Burns (right) came to the Sanibel area in the early 1920s from Beaufort, South Carolina, with his wife, Mary, and two nephews, Peter and Herbert. Together with Isaiah Gavin and his sons, Peter cleared a 99-acre tract of land on the bay for the Mayer family. On this land, along with a small citrus grove, the Mayers built two homes ordered and shipped from the Sears Roebuck catalog. In 1942, Peter died a tragic death under suspicious circumstances. The below picture shows, from left to right, Peter Burns, Sherwin Mayer, and Herbert Burns swimming in the gulf with friends in the late 1920s. Mary and the two nephews had returned to Beaufort, South Carolina, during the Depression, several years before Peter's tragic death.

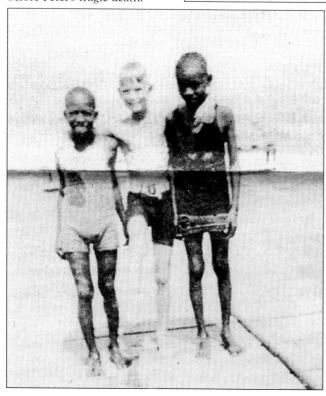

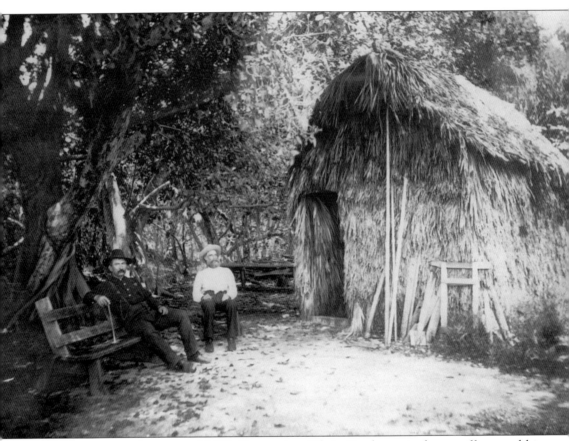

In this picture taken around 1895, Commodore Edwin Reed, a retired navy officer, and his neighbor Capt. Sam Ellis relax in front of Reed's palmetto shack house on Sanibel's Tarpon Bay. The shack built from palmetto leaves is similar to fishing shacks located in the area. Reed and Ellis both homesteaded on the bay, Reed along its western shore and Ellis on the southern shore. Reed was unrelated to the William Reed family to the east on San Carlos Bay. Commodore Reed's neighbors were the Woodrings, who settled on the eastern mouth of the bay. Commodore Creek leading into Tarpon Bay got its name from the Reed homesite.

Esperanza Woodring walks down the drive from her Sanibel home on Woodring Point in the 1940s. The low, shed-like roofed building in front of the house is the family's water cistern, which collected rainwater for drinking purposes. At right is a picture of Charlie McCullough standing in front of the McCullough home on Woodring Point. Albert McCullough, Charlie's grandfather, along with a group of Cincinnati businessmen, built the structure as a clubhouse for their fishing expeditions. The clubhouse was located next door to Sam Woodring, their fishing guide. Albert built the house himself from yellow pine, a wood so tough that holes have to be drilled before nails can be inserted. The clubhouse is over 100 years old and still occupied by McCullough's descendants. Charlie is a well-known photographer on Sanibel Island. (Courtesy of Mary Irving collection.)

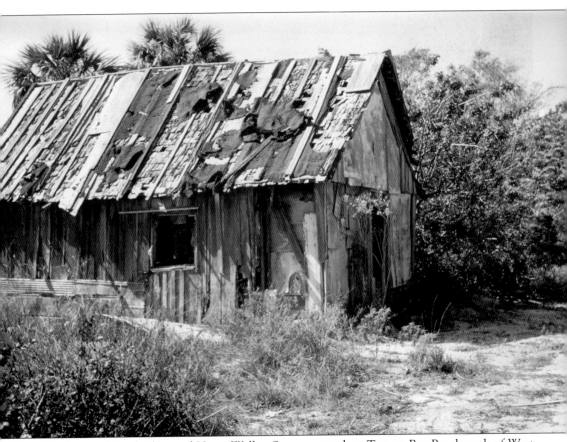

The home of Pearl Alice and Harry Walker Sr. once stood on Tarpon Bay Road north of West Gulf Drive. The house was home from the late 1940s to the late 1970s. Harry Sr. passed away in 1969, and Pearl Alice remained in the Walker home for many years after the death of her husband. The historical but run-down home was demolished in June 1996.

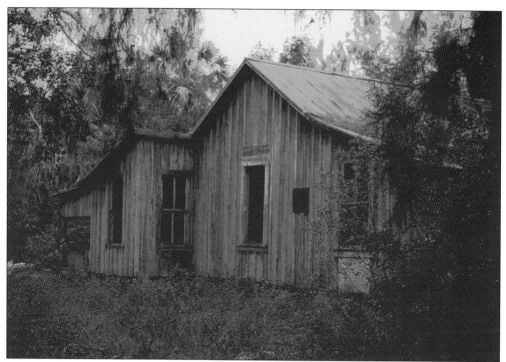

Carl and Mozella Jordan lived in this house on Wulfert Road from the early 1950s until they purchased their home on Old Trail Road in 1969. The Jordans were the first black couple on Sanibel to purchase land in their own name. They remained in this home until Mozella's death in 2007. Carl was the grandson of early pioneers Harry Walker Sr. and Pearl Alice Walker. In the photograph below, the Jordans, with their three sons (from left to right), James Jr., Anthony, and Harry Jordan, stand in front of the Gavin family home on Easter Sunday in the late 1950s. (Courtesy Jordan family.)

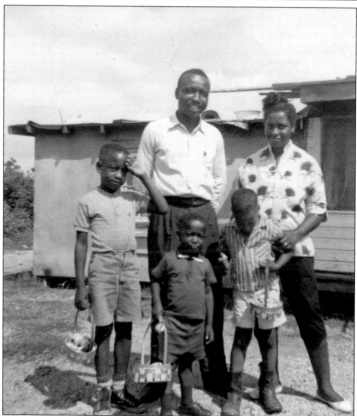

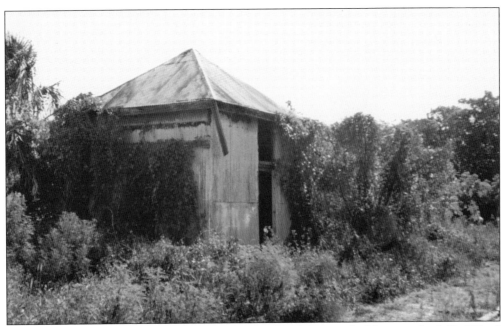

The historic Gavin Telegraph House was a 10-foot-by-10-foot tin building on the J. N. "Ding" Darling National Wildlife Refuge grounds. This building served as the sleeping quarters for the Gavin children during the years that the family lived on the property. It was known as the telegraph house because it was reportedly a receiving station for the message that the battleship *Maine* had been sunk. It was the first contact point for telegraphed messages to this country from Cuba. The historic building was destroyed in a controlled burn on the refuge property on May 29, 1992. Below is a photograph of servant dwellings in the rear of the premises of the old Island Inn Lodge property around 1910. (Courtesy Island Inn.)

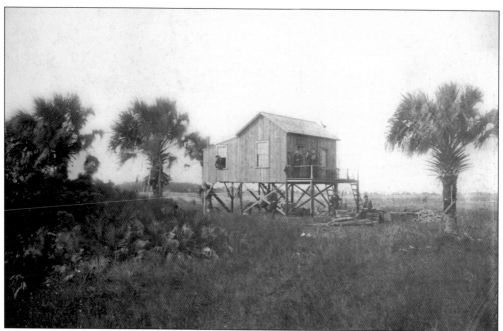

Above is a picture of the first home for Rev. George O. Barnes and his family when they arrived from Kentucky to homestead on Sanibel in 1889. It was a small stilt cottage on Tarpon Bay, and they ascended by ladder (left) to their abode. Below is the Sanibel House at Reed's Landing around 1911. Owned by Lucy Reed Daniels, this house was once a floating hotel for visitors and fishermen. The children in the picture are, from left to right, J. B. Daniels, Hazel Reed, Carrie Reed, and Haskell Daniels.

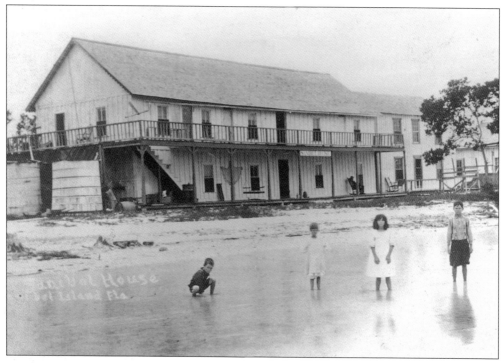

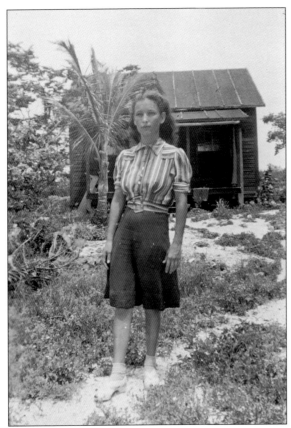

In this 1940s photograph, a young woman (maybe a relative of Esperanza Woodring) stands in front of a cottage on Woodring Point. The cottage was probably used for visitors that came to Sanibel to relax and enjoy the "riches" of the island. The picture below is typical of the fish houses sprinkled throughout Pine Island Sound and Charlotte Harbor, two major waterways that touch Sanibel. The Punta Gorda Fish Company provided ice to these structures so that local fishermen could preserve their catch, which was picked up by the company, packed, and shipped to northern markets.

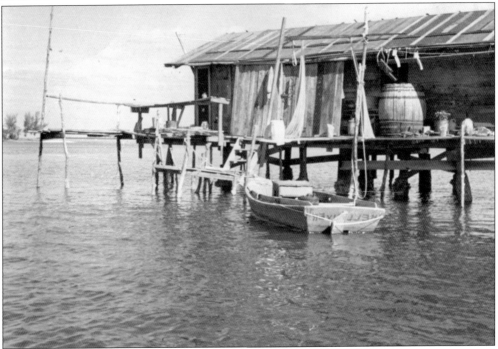

Two

HARVESTING THE SEA

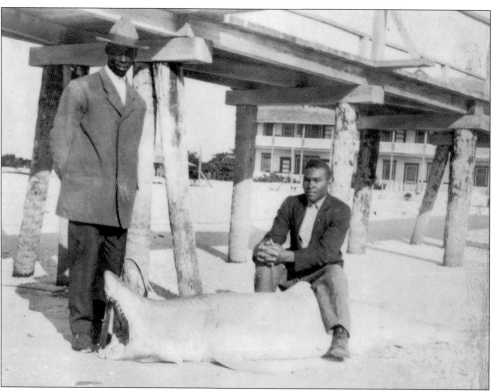

In this photograph, two unidentified local fishermen proudly display their daily catch on the beach in front of the Island Inn Hotel c. 1910. Fishing was not only a sport at that time, but also became a popular commercial venture. As seen in the photograph, it was not uncommon to catch sharks off the island shores. Shark skins were sent to a factory and processed into leather, their livers into oil, and their fins shipped to Hawaii. The shark meat and intestines were used for fertilizer and soap, and the cartilage was made into glue. Shark hides were salted and shipped all the way from Sanibel to a tannery in New Jersey with headquarters in New York. The company president lived on Sanibel. (Courtesy Island Inn.)

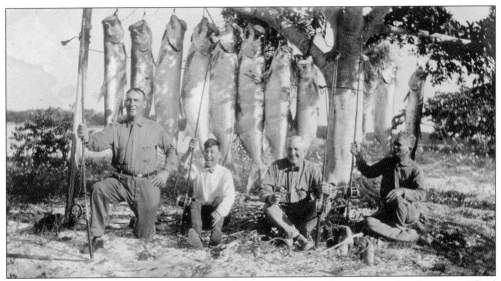

Four unidentified happy fishermen pose with 10 tarpon hung from a strangler fig tree at Blind Pass on Sanibel. Blind Pass is a narrow channel of water that separates Sanibel Island from Captiva Island. The above photograph was taken between 1910 and 1920. Below, a fish-house operator in Tarpon Bay on Sanibel scrapes mullet and ice down a chute into the fish runboat for shipment to Punta Gorda and then by rail to destinations north around 1940. The runboat brought ice and picked up fish catches from a string of fish houses that extended into the Ten Thousand Islands.

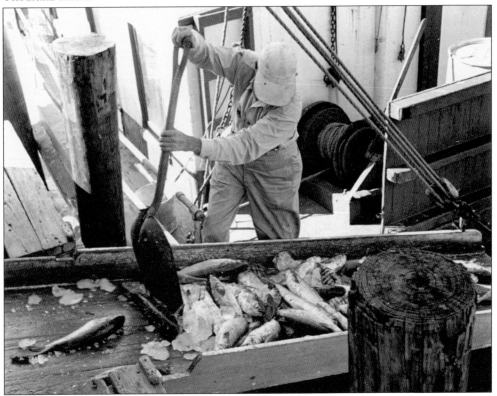

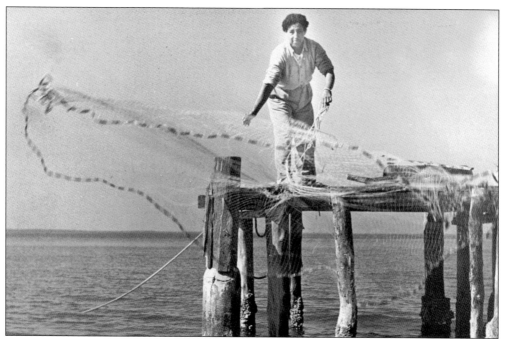

Esperanza Woodring throws a cast net from her dock on Woodring Point at the mouth of Tarpon Bay in the 1940s. Born on Cayo Costa in 1901, she married Sam Woodring and moved to Sanibel, where after her husband's death in the 1940s, she continued his fishing guide business until the late 1980s, becoming renowned for her expertise in what is largely a man's world. Esperanza Woodring died in 1992.

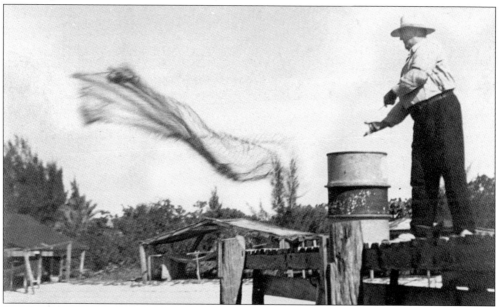

Sam Woodring is also shown throwing a cast net at Woodring Point around 1942. The son of Sam B. Woodring, who homesteaded on the point in 1888, Sam was a well-known fishing guide and had a reputation as a bootlegger in earlier years. He was a generous contributor to island projects, such as the construction of the Sanibel Community House. He died in the early 1940s.

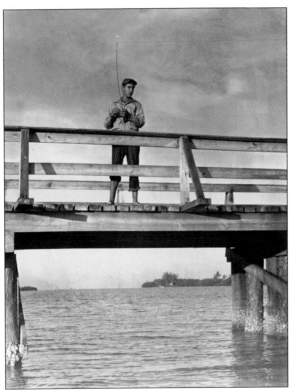

Ralph Woodring fishes from the old wooden bridge spanning Blind Pass in the late 1940s. Woodring is the grandson of homesteader Sam B. Woodring and the son of Sam and Esperanza Woodring. The wooden bridge was replaced in 1954 with a concrete structure, and the first Blind Pass bridge connecting Sanibel and Captiva was constructed in 1918.

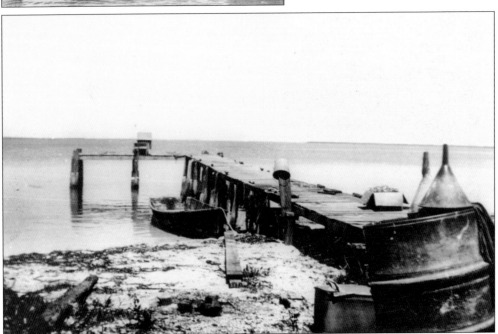

The Woodring family dock, at the mouth of Tarpon Bay on Woodring Point, looks into San Carlos Bay on the north shore of Sanibel. The dock is used recreationally, for guiding trips, and for bait shrimp collection. The Woodring family homesteaded on the point in 1888, and generations of the family have been fishermen and guides on the island. The dock is pictured in the 1950s.

Esperanza Woodring stands in her guide boat in the 1940s with her cast net at her dock near Tarpon Bay on Sanibel. Esperanza spent her long life on the water, being the child of fishermen from Cayo Costa and marrying into the Woodring family. Her husband's death catapulted her into the guiding business to support her family when she was about 40 years old.

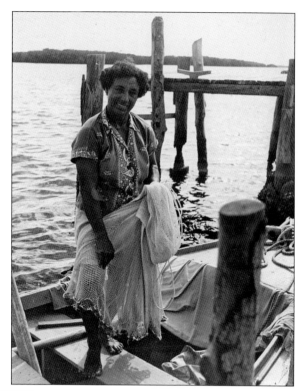

Esperanza Woodring tends a cooking fire at Duffy's Creek in the mangroves on the north side of Sanibel in the 1940s. Fishing guides often cooked lunch for their party while fishing, and she holds a mangrove branch with coon oysters to roast over the fire. Duffy's Creek was named for an early homesteader and is within the J. N. "Ding" Darling National Wildlife Refuge.

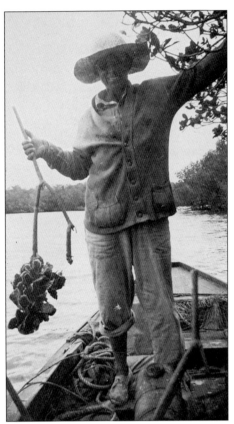

Esperanza Woodring gathers coon oysters, which grow attached to the mangrove prop roots, for an oyster roast in the 1940s. In the photograph below, from left to right, Sam Woodring, "Leana" (possibly a member of the Padilla family), and George Underhill are pictured in the 1920s on the porch of the Woodring house with cast nets hanging to dry from the porch rafters behind them on Woodring Point. Underhill, a fisherman, was a friend of the Woodrings who lived on the south shore of Tarpon Bay. His stepfather, Sam Ellis, was an early homesteader, and his mother a Civil War widow.

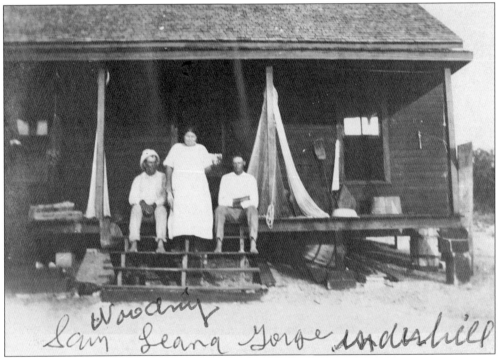

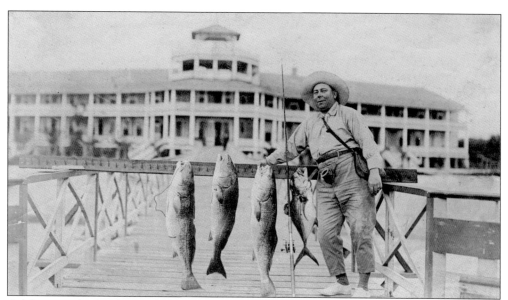

A fisherman displays his catch, including a snook and redfish, on the dock leading to the massive wooden Tarpon House around 1910 in the photograph above. Fishing, particularly tarpon fishing, was wildly popular before and after the beginning of the 20th century, and a hotel at St. James City and this one were built to accommodate the crowds. It was located to the left as one crosses the causeway, where condominiums stand today. The photograph below, from the Barnes family album, shows a group of unidentified people fishing from a San Carlos Bay dock for sheepshead and redfish, by handline and gig, around 1890.

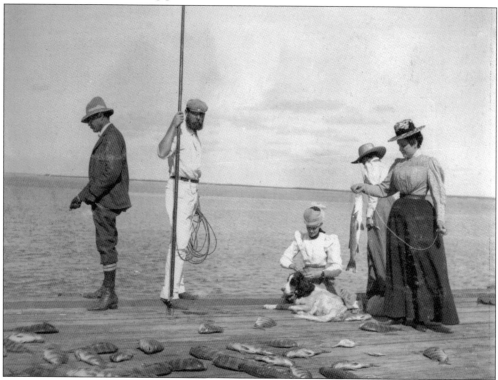

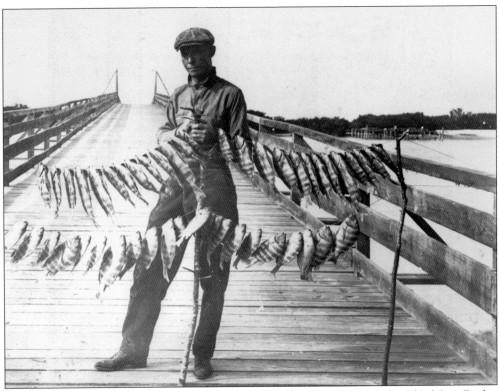

In the picture above, Dean Mitchell displays four dozen sheepshead on the Blind Pass Bridge between 1910 and 1920. Blind Pass was well renowned at that time as one of the best fishing locales in southwest Florida. Currently the pass is closed due to excess sand deposits, which make it impassable. Captiva Erosion Prevention District has recently submitted plans to the State of Florida to dredge and reopen the pass. The building in the photograph below, seen between 1914 and 1920, was along the water where a dock reached out to a channel cut by the county to provide boats access to the town and its produce. The land in the background is the Wulfert Keys.

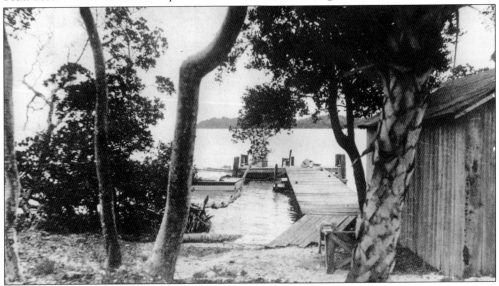

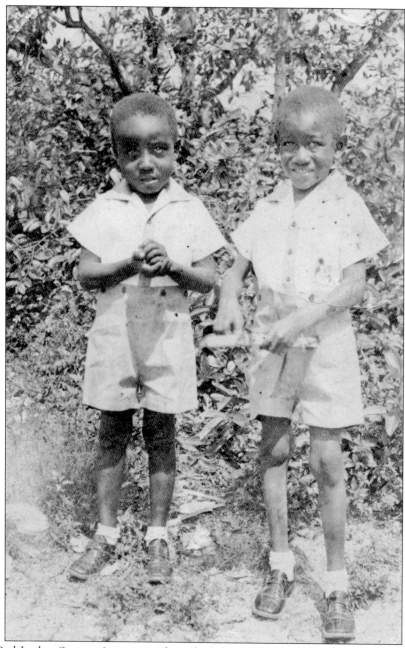

James Carl Jordan Sr., age 6, is pictured on the left with his uncle Nathaniel Walker at their summer job gathering shells on the beach in 1938. In an interview for a local island newspaper, Carl remembered earning $1 per bushel for the more common shells and $8 per bushel for the rare pectens. Born in 1932, Carl was the first black child born on Sanibel Island. He was raised by his grandparents, Harry Sr. and Pearl Alice Walker. As a young boy, the lifelong resident learned to be a jack of all trades, mostly helping with farming chores but also doing whatever had to be done around the homestead. As an adult, he was an electrician, carpenter, painter, and general handyman. Carl resided on Sanibel with his family until his death in May 2005. Sixth-generation Jordans live on Sanibel today. (Courtesy Jordan family.)

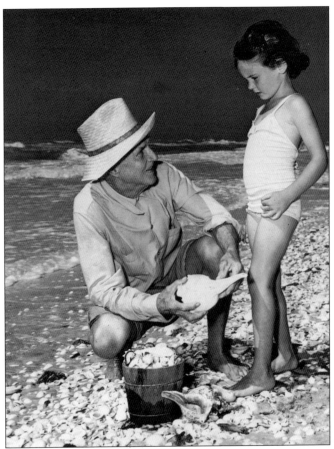

An unidentified man and child collect shells on a Sanibel Beach in the photograph above. Sanibel is world famous for its abundant shells, and shell collecting is a favorite pastime of residents and winter visitors. The Bailey Matthews Shell Museum on Sanibel is one of the few shell museums in the world. Below, a group of unidentified women look over a Sanibel shell display at the Kinzie ferry office in the 1950s. The Sanibel Shell Fair started in the 1930s and still attracts thousands from around the world. (Courtesy Southwest Florida Museum of History.)

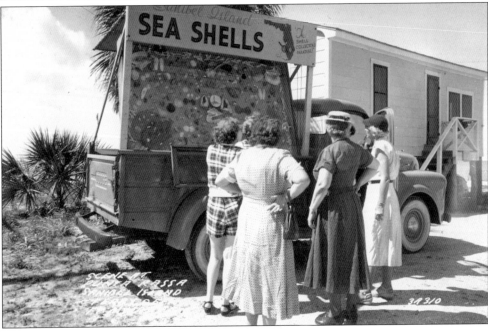

The photograph above displays the logbook from the 11th Annual Sanibel Shell Exhibit, held on Sanibel in March 1947. A page from the book displays the signatures of Esperanza Woodring, entry No. 1160, as well as Scotia Bryant (No. 1161) and Rosa Bryant (No. 1166), all longtime Sanibel residents. The shell fair began in 1906 and became an annual tradition that still continues to this day. It was a popular event, and many participants spent long hours working on their creations in anticipation of winning a coveted prize. (Courtesy Francis Bailey.)

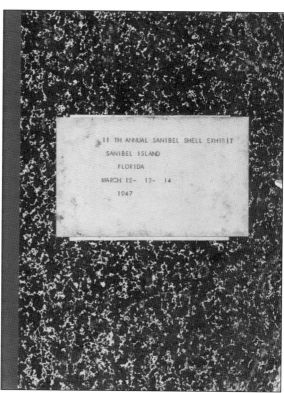

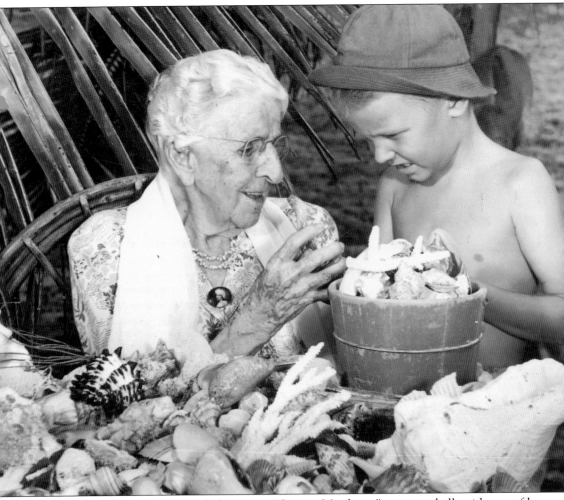

Hallie Matthews, affectionately known as "Granny Matthews," inspects shells with one of her grandsons in the 1950s. Granny Matthews directed the shell fair for many years and also coauthored a shell reference book. Matthews was a true pioneer whose determination and sense of grace and standards built a world-class family-style vacation retreat. Under her guidance and direction, the Island Inn became a success and was able to outlast all the other early Sanibel lodgings. Matthews died in 1950 at age 94. (Courtesy Island Inn.)

Three

DEVIL STICK MINT

Mosquitos were a constant problem in the early days on the island. This photograph depicts the view of the gulf through a palm tree–lined shore. Oscar Gavin, a pioneer from the early 1900s, stated in his oral history that one of the best mosquito protection methods was to take advantage of the palm trees and the gulf breezes. Early settlers made swishers from the dried palm fronds to brush away the swarms of mosquitoes. Also, according to Gavin, the pioneers often made a concoction called "Devil Stick Mint" from a native plant and sprayed it to ward off the mosquitos and other pesky insects. The plant may have been the same as Devil's Walking Stick (a large shrub or small tree with club-shaped branches, root sprouts, and berries).

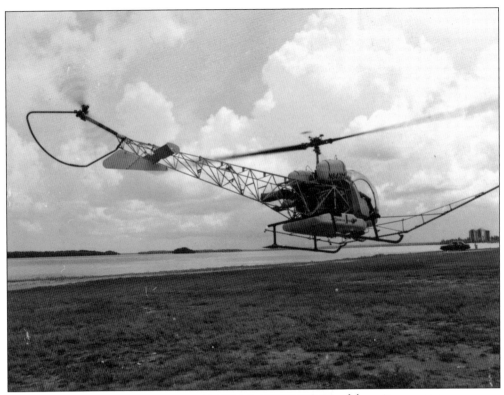

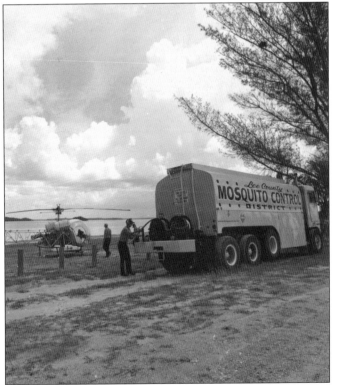

Mosquitoes were a tremendous problem on Sanibel. Early explorers told stories of sleeping on the beach covered in sand to escape the pests. The Lee County Mosquito Control District is most responsible for the ability of people to live in southwest Florida. They used helicopters and C-47 planes to spray larvicide and adulticide to control the mosquito population and allow residents to survive during the warm weather. Both of these pictures depict mosquito control in action. During the winter months, the mosquito planes and helicopters are serviced and maintained to be ready for the extremely busy months of spring, summer, and fall. (Courtesy Charles McCullough.)

In the 1940s, Sanibel was known for both shelling and mosquitoes. At that time, the mailman delivered mail in July dressed in Eskimo clothing for protection. On the island, mosquito traps were set in residents' backyards. On September 15, 1950, a world-record number of mosquitoes was collected in a single trap by the ferry landing: 365,696. The causeway played a major role in assisting with mosquito control. Soon after the causeway was built, small tanker trucks used it as a portable insecticide refilling station for the helicopters to refuel. Today, with more effective use of chemicals available to them, control planes use only one load of 120 gallons of either larvicide or adulticide for an area of coverage. Spraying is usually done very early in the morning so that the process is finished before children leave for school. (Courtesy Charles McCullough.)

Edmund Gavin (left) was a sharecropper, landscaper, and inventor who devised a method to deal with the swarms of mosquitoes that made life difficult for his growing family. He designed the first automatic mosquito-control defogger. Edmund Gavin's father, Isaiah Gavin, was the first black settler to homestead on Sanibel in 1917. Eugene Gavin, son of Edmund and Elnora Gavin, remembers the fun times growing up on Sanibel: going to the beach, shelling, or playing in the woods. However life was not just about playing or having fun. Gavin recalled, "We never had to worry about food, but everyone worked very hard. And the mosquitoes did not make things any easier." Mosquito swarms often covered windows and blackened screens, making day appear as night. (Courtesy Eugene Gavin.)

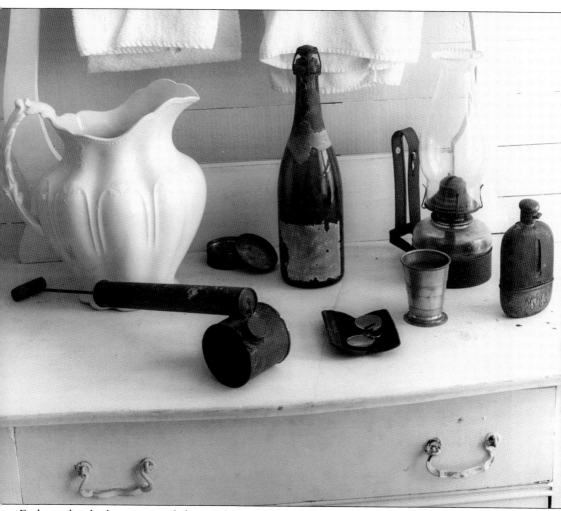

Early settlers had to cope with horrendous mosquito and no-see-um invasions. A smudge pot kept burning around the yard helped to control and protect island residents from the descent of the swarms, especially in the evenings. Another way to protect the family and the home was to generously coat the screens with pungent turpentine and kerosene. In this picture, a typical survival kit is placed on the nightstand in the bedroom of an early island resident. Included in the survival kit were a fogger, salve, and a medicinal flask. Traditionally, netting was placed over the bed to shield sleepers from the relentless hordes. Even with the extreme heat, protective clothing had to be worn while walking miles to school or to the store. Keeping an ever-present pitcher of cool, fresh cistern water next to the nightstand could also help to bathe away the hurt from the legions of insects that persisted even into the fall or winter season. (Courtesy Charles McCullough.)

Esperanza Woodring entertains a group of "screw-worm" experts at a dinner party. E. F. Knipling, at her side, field tested his concept of sterilizing the insects, leading to a huge advance in insect control. Dad White is standing, and Ralph Woodring is second from the right. This photograph was taken in the early 1950s.

The old ferry dock in front of the Bailey general store shows Mary Ann McCullough "boardwalking" in the early 1950s. According to T. P. Wayne Miller, former longtime director of Lee County Mosquito Control, "the highest mosquito count ever recorded on planet earth was on the ferry dock in 1950." (Courtesy Mary Irving collection.)

Four

LIGHTING THE WAY

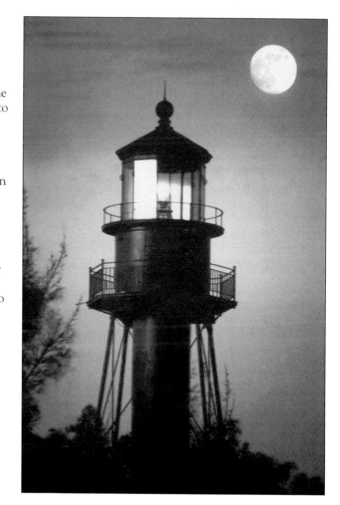

The Sanibel Lighthouse with the full moon overhead was a sight to behold for residents and visitors alike. It represented life, family, home, and safety upon entering the waterways surrounding the island of Sanibel. It was a beacon of hope for all. The nearest lighthouses on Florida's coast at that time were at Key West and at Egemont Key off the Tampa coastline, almost 300 hundred miles apart. As shipping steadily increased in the gulf, and as Punta Rassa lay between the two lighthouses and was developing a major trade connection with Cuba, the Sanibel Lighthouse become almost a necessity. It became the first lighthouse along the west coast of Florida sailing north from Cuba. Trade with Cuba ended with Castro's rise to power, and Punta Rassa's days as a port ended when the Sanibel causeway was built in 1963. (Courtesy Mary Irving collection.)

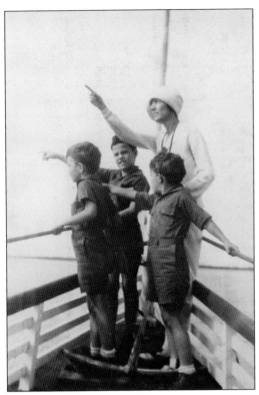

This photograph shows, from left to right, John, Francis, and Sam Bailey with their mother, Annie Meade Matthews Bailey, at the bow of the *Success* ferry crossing San Carlos Bay to Sanibel from the mainland and pointing ahead to the lighthouse around 1928. Below, looking to the northeast along a path to the gulf, the Sanibel Lighthouse stands in the trees behind the western keepers' quarters. The light from the lighthouse can be seen for 16 miles out to sea. The lighthouse converted to electricity in 1962. One year later, an electrical outage caused it to go dark for one week, ruining its 79-year perfect record for continuous power. (Left, courtesy Mary Irving collection.)

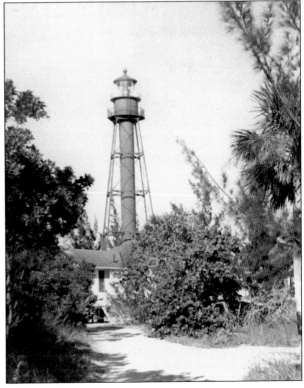

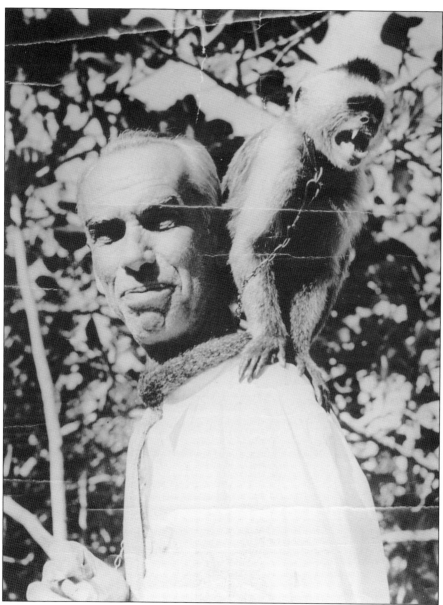

In the photograph above, Webb Shanahan plays with his pet monkey. Shanahan came to Sanibel from Key West with his family when he was two years old. Shanahan was an assistant lighthouse keeper, helping his father Henry, who was the lighthouse keeper from the late 19th century until about 1912. His wife, Pearl, was the innkeeper at the Palms Hotel, which she ran with her mother, Irene Rutland Shanahan. When not performing his lighthouse keeper duties, he delivered mail on the island, not by horse but by car, making him the first mailman in the county to do so. Shanahan was also a member of an Inter-Island Conservation Commission, which formed to help enforce state and federal game laws and improve efforts to preserve the waterways around Sanibel and Captiva. His efforts, in conjunction with cartoonist J. N. "Ding" Darling and others on the commission, eventually led to the creation of the J. N. "Ding" Darling Wildlife Refuge. The Sanibel National Wildlife Refuge was officially established in 1945 and included all of Sanibel and the southwest tip of Captiva.

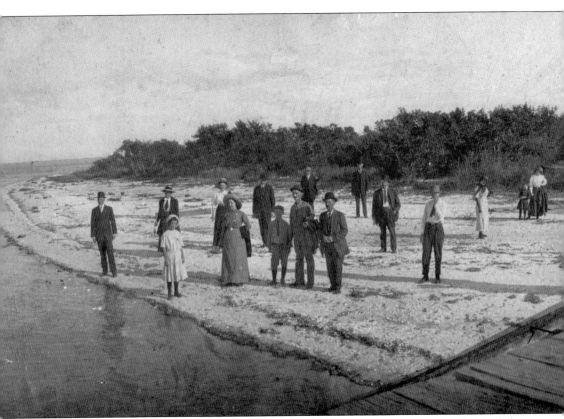

This picture depicts a group of unidentified early settlers standing on the Sanibel Lighthouse dock before the beginning of the 20th century. Given their formal attire, the group appears to be awaiting the arrival of a ferryboat with much anticipation. Around the time this photograph was taken, the Sanibel Lighthouse's kerosene lantern was activated for the first time. Considering the time frame, one could only speculate that the group might be expecting a government official to

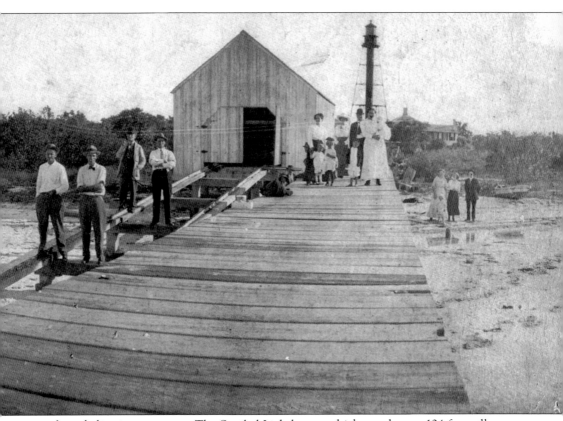

arrive for a dedication ceremony. The Sanibel Lighthouse, which stands over 104 feet tall, was first illuminated by a French-built light lens designed by the French physicist Augustin Fresnel in 1822. This amazing structure has served as a landmark to all passing ships for over 100 years now. (Courtesy Southwest Florida Museum of History.)

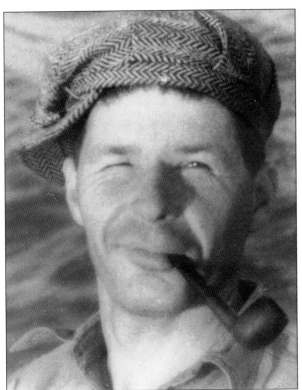

Roscoe F. McLane ("Mac"), pictured at left, was a lighthouse keeper and an assistant lighthouse keeper in the 1930s. This photograph was taken in 1934. Mac McLane died at the very young age of 38 in 1938 after emergency surgery for acute appendicitis. In the photograph below, Roscoe "Mac" McLane, left, shakes hands with Sam Woodring in the 1930s. Woodring and McLane were both generous supporters of many local community projects, one of them being the Sanibel Community House, which was built in 1929. This community house served as a popular gathering spot for islanders to hold parties and social functions, especially in the late 1920s and early 1930s. It still remains in its original location today on Periwinkle Way and continues to play an active role with community activities, including the annual shell fair.

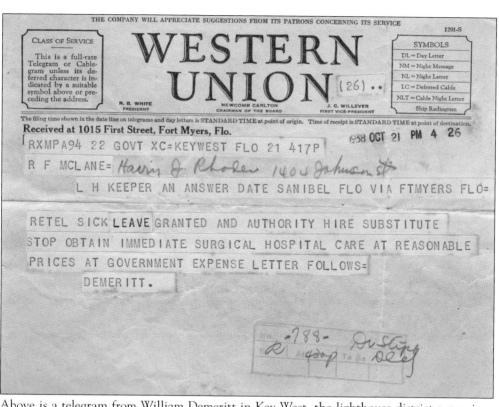

Above is a telegram from William Demeritt in Key West, the lighthouse district supervisor, authorizing sick leave for Roscoe McLane when he was stricken with appendicitis while serving as the assistant lighthouse keeper on Sanibel in 1938.

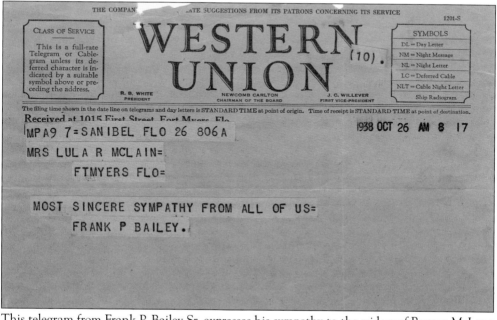

This telegram from Frank P. Bailey Sr. expresses his sympathy to the widow of Roscoe McLane after her husband died in 1938.

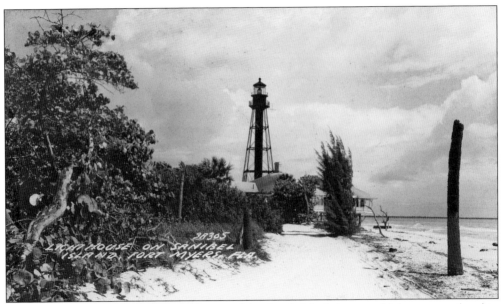

The photograph above shows an early view of the Sanibel Lighthouse, which was completed in 1884. As the population on Sanibel was scant at that time, the lighthouse keepers were somewhat isolated. After 1888, that began to change. That year brought many hopeful farmers to Sanibel. The Homesteading Act opened up much of the land on Sanibel except for the east end of the island, which was reserved for the lighthouse. Homesteaders could claim as much as 160 acres of public land. The only provisions were that one be an American citizen, head of the household or 21 years of age, and have never borne arms against the United States government or aided its enemies. The first influx of Sanibel homesteaders began to arrive and the farming industry started to blossom. Below, the Sanibel Lighthouse historical marker stands in front of the lighthouse tower. It was permanently placed there in 1974.

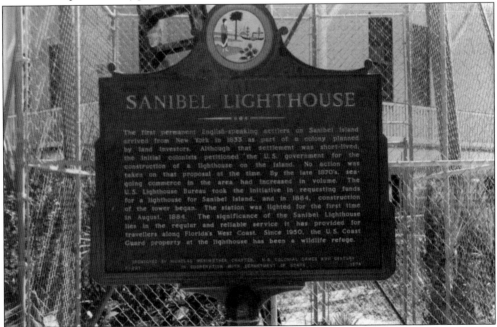

Five

COMINGS AND GOINGS

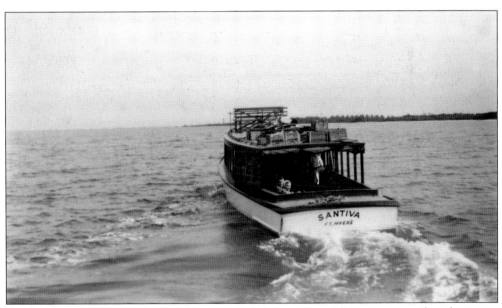

The *Santiva* mail boat prepares to dock on Sanibel in the 1950s, with its passengers aboard enjoying their trip down river from Fort Myers. The *Santiva* would leave the mainland every morning, except for Sundays, and return late in the afternoon. The mail boat served several functions in addition to mail delivery, including transporting passengers and freight to stops that included Punta Rassa, St. James City, Sanibel, and Captiva. (Courtesy Mary Irving collection.)

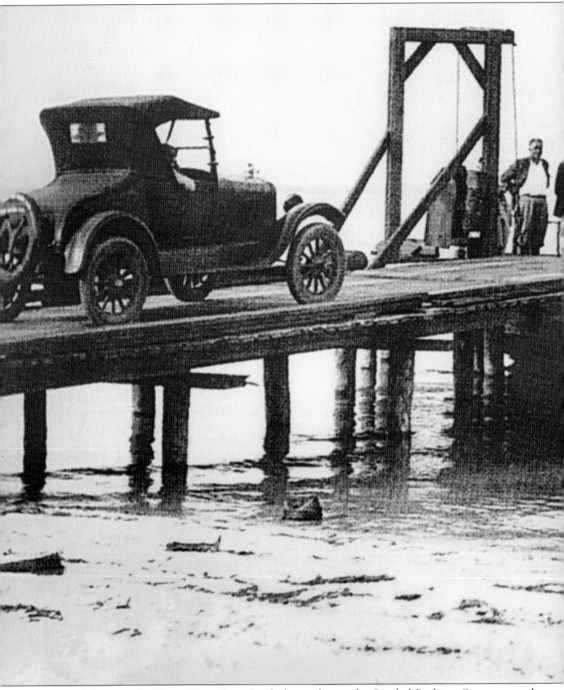

Pictured above is the Kinzie Ferry Boat Dock, located near the Sanibel Packing Company and general store from the 1920s. This picture shows a line of automobile owners waiting to board the ferry for transport to the mainland. In 1926, regular ferry service began from Sanibel to Punta Rassa. The ferryboat could carry seven cars at a time and a handful of passengers, making four trips per day. The cost was $1 per vehicle and 50¢ per passenger. Famous visitors such as Thomas Edison and Henry Ford were regular passengers. Ferryboats made it possible for more tourists

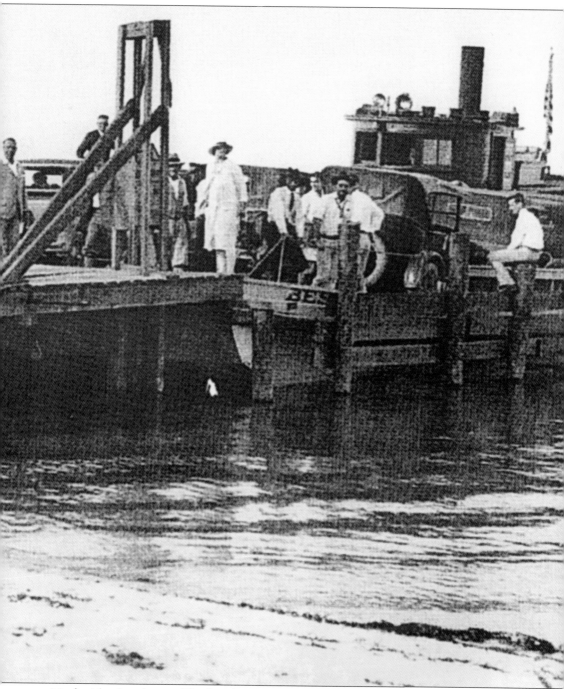

to visit the island each year. The hotel and hospitality industry grew and became prosperous. Sanibel was host to other famous and nationally recognized visitors such as Charles and Anne Lindbergh, who honeymooned here in 1920, and poet Edna St. Vincent Millay, who visited Sanibel and stayed at the Palms Hotel, all coming over from the mainland on the ferry. The original Kinzie Dock was destroyed in the hurricane of 1926, as was the Matthews Wharf and the original Sanibel Packing Company.

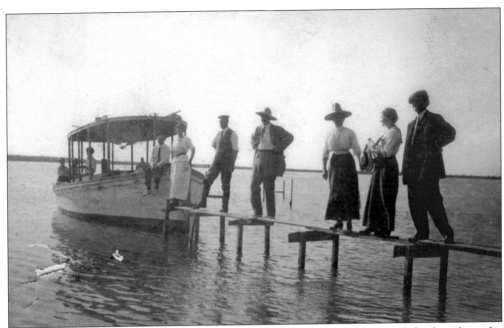

An unidentified group of people are pictured above standing on a footplank leading from the south shore of Tarpon Bay. It appears as though they are waiting to go onboard as the boat pulls up to the dock sometime between 1895 and 1908. The Gibson family and neighbors, pictured below, gather at the Wulfert Point landing as a supply or mail boat prepares to dock in the early part of the 20th century. This was probably a much-anticipated part of the day, as this was their lifeline to the mainland.

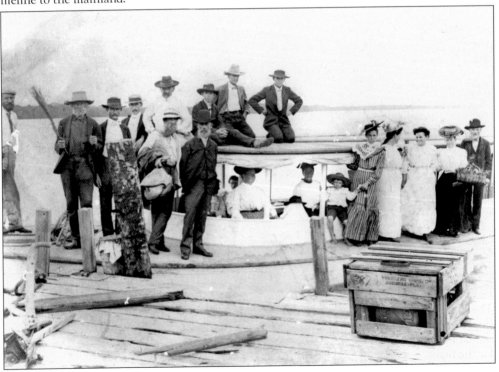

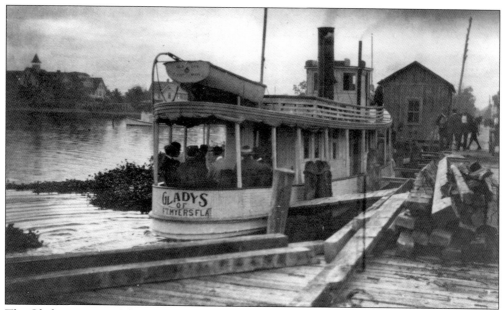

The *Gladys* was part of the Kinzie Brothers steamer line and had ties to Sanibel from 1902 until it sank in 1936. After sinking in shallow water off Sanibel, the *Gladys* was designated a navigational hazard and was destroyed.

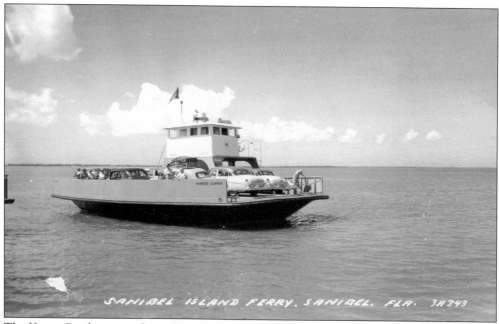

The Kinzie Brothers auto ferry, the *Yankee Clipper*, is filled with cars and travels on San Carlos Bay in the early 1950s. The ferries made regularly scheduled runs to and from the island. If one should happen to miss the last ferry back to the mainland, one would most likely be stranded for the night.

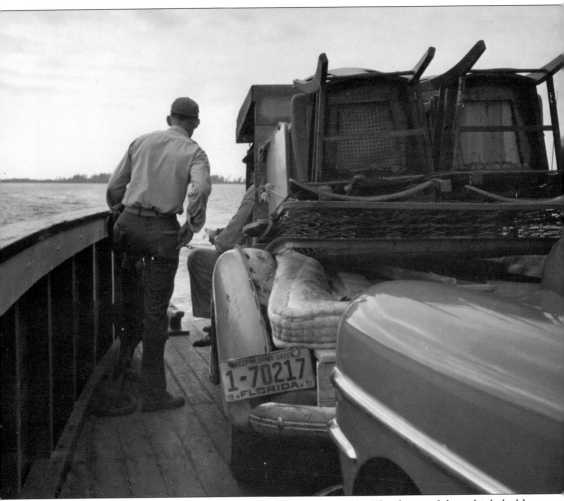

Unidentified men transport furniture by auto ferry in the 1950s. The driver of the vehicle holds two $1 bills in his hand, possibly the fee for the ferry service. Moving furnishings onto the island from Fort Myers by ferry was a common practice. (Courtesy Charles McCullough.)

Winter resident Peggy Sawyer poses on Bailey's dock in 1925 next to the Crown gasoline pump. Gas was delivered in large drums, stored in a retainer, and pumped into tanks on the dock. Vehicles were refueled on the dock.

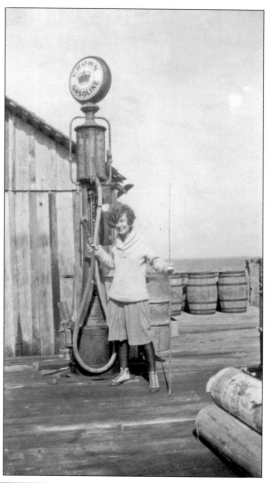

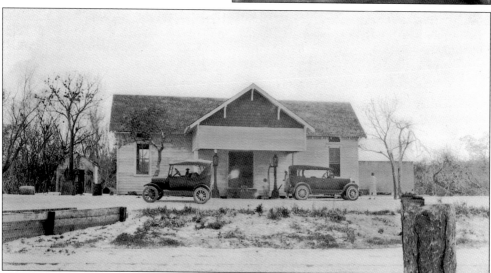

The Bailey general store is seen from the dock in the 1950s. The Bailey store was the hub of the community on Sanibel for many years. (Courtesy Mary Irving collection.)

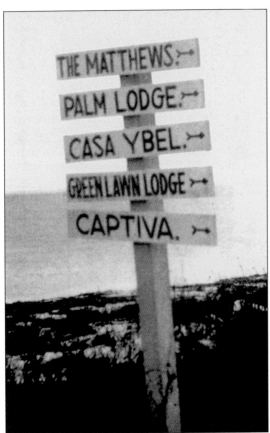

The photograph at left depicts a directional sign for visitors to Sanibel. As more and more visitors were attracted to the island, the demand for food and lodging increased. The hospitality industry grew as a result of this and became a large source of commerce for Sanibel, replacing the farming industry. (Courtesy Mary Irving collection.)

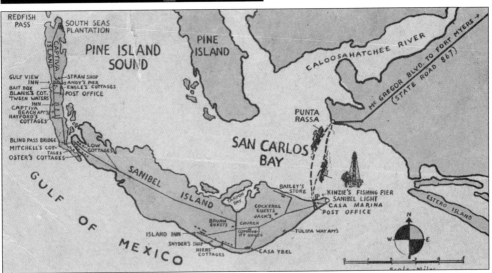

This map of San Carlos Bay shows the surrounding islands and mainland, the main roads on Sanibel and Captiva, the approach to Punta Rassa, a number of island businesses and landmarks, and the ferry line's route between Punta Rassa and Sanibel across San Carlos Bay. The Kinzie Line operated the ferries from 1928 until 1963, when the Sanibel Causeway was opened. (Courtesy Mary Irving collection.)

The photograph at right of Clarence Rutland and his wife, Ruth Wiles Rutland, is from the 1930s. Clarence Rutland farmed, did roadwork, made deliveries, crated vegetables in packinghouses, and, among other things, was an assistant lighthouse keeper for many years. At one point, he delivered shells from the beaches of Sanibel to the Fort Myers home of Thomas and Mina Edison. Like Mina Edison, the unidentified women in the photograph below appreciate and enjoy the beauty of Sanibel shells.

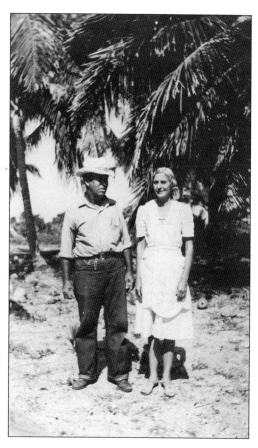

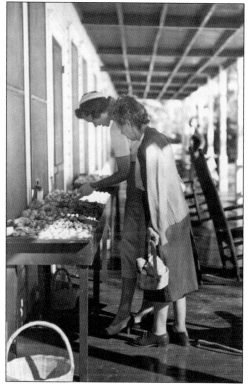

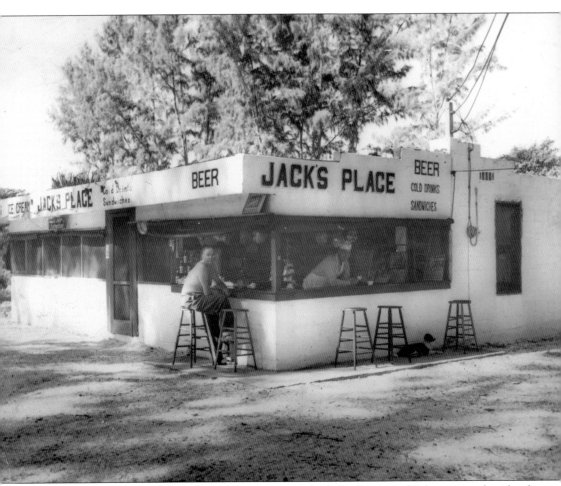

Jack's Place in the late 1940s was the first sandwich and soft drink establishment on the island's main road. In 1949, Jack Cole, an ex-marine, built this business for himself and his wife, serving customers on stools placed outside the restaurant. He soon remodeled, adding tables inside and serving everyone family-style, whether they knew each other or not.

Mozella Belin Jordan came to Sanibel in the late 1940s. She met and married James Carl Jordan in 1952. They remained island residents all of their lives, raising four sons on Sanibel. Mozella was an advocate for civil rights and was instrumental in the integration of church and school. For 45 years, Mozella was a much sought-after island caterer. Her legacy lives on even after her death in 2007. The picture below shows James Carl Jordan, a lifelong resident of Sanibel who was raised by his grandparents, Harry Walker Sr. and Pearl Alice Walker. He worked as a handyman, electrician, master carpenter, and painter until his death in May 2005. His sense of humor was legendary, and his name is mentioned daily in popular island locales. (Courtesy Jordan family.)

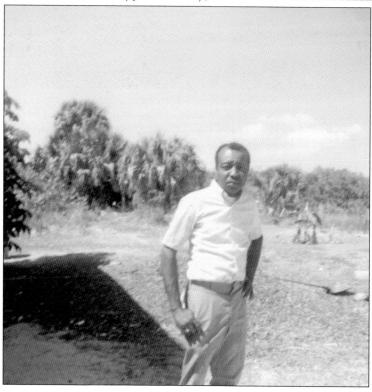

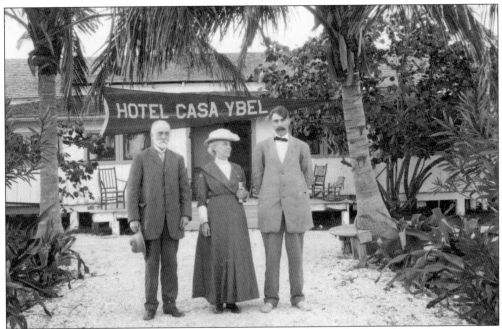

This photograph of three unidentified people was taken in front of the Casa Ybel Resort in July 1912. Rev. George O. Barnes and family came to Sanibel to homestead in 1889 and opened a hotel near the gulf. Called the Sisters, the hotel later was renamed Casa Ybel in 1909. That same year, the annual shell show was held at the hotel for the first time. The Barnes family was known for elegance at the Sisters Hotel (later Casa Ybel Resort), as their dining room, in the picture below taken in the 1890s, shows. They decorated with native materials and had fashion shows and parades, contests, and parties, including shell shows. (Courtesy Island Inn.)

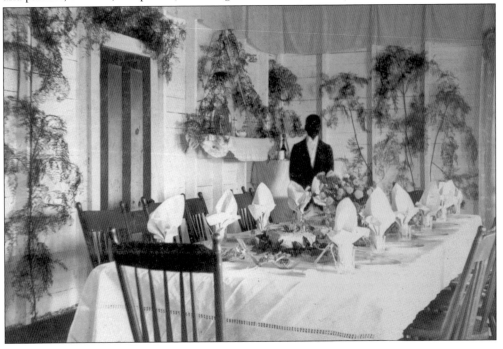

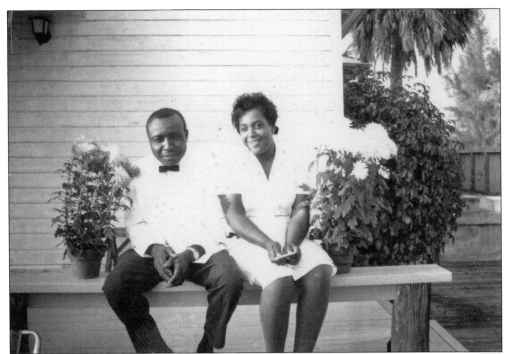

James Carl Jordan and Mozella Jordan take a short break while working together in March 1968. Carl and Mozella met on Sanibel in the late 1940s. They were both employees of the Casa Ybel Resort. Under the direction of the head chef, Mozella mastered the culinary skills that led to her subsequent career in catering. The kitchen staff at Casa Ybel Resort on Sanibel gathers around the table below in the early 1950s. At far left is Queenie Hurst, with Chef Ernest ? next to her. First on the right is Carl Jordan, and seated next to Jordan is Charlie Hurst. Other staff members in the photograph are unidentified. (Courtesy Jordan family.)

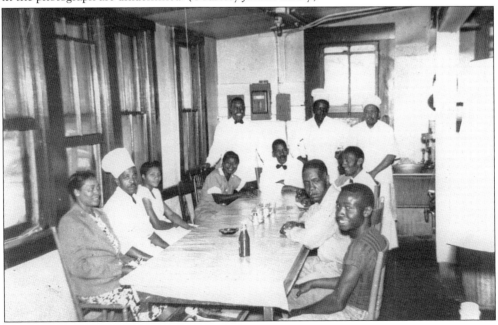

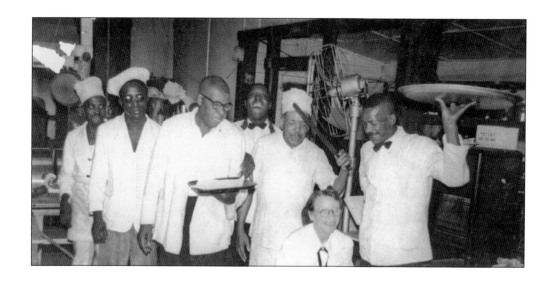

Unidentified staff, chef, and waiters clown around with employee Mandie Hayes, seated in front, in the kitchen at Casa Ybel Resort in the early 1950s. The picture below shows Chef Chester ? on the left and his assistant Berry ? at the steam table in the kitchen of Casa Ybel Resort in 1951.

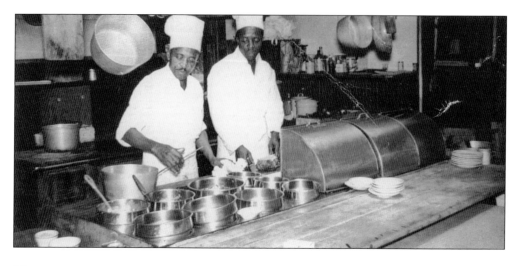

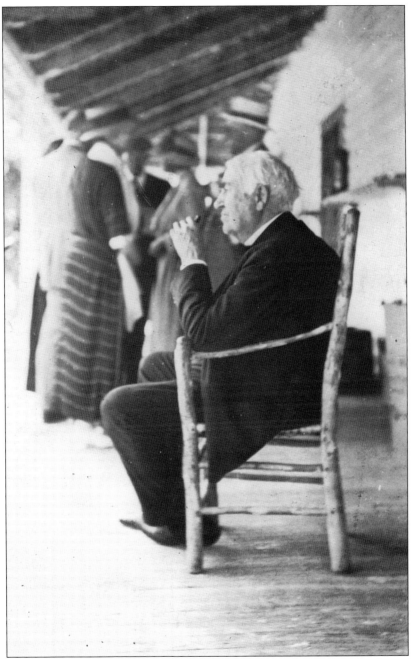

Thomas Edison is pictured above as he visits the Casa Ybel Resort on Sanibel in the early 1900s. Edison visited often, examining and researching many of the islands plants for possible economic application. The chair he is sitting in on his Casa Ybel cottage porch was hand-constructed from branches. Edison and his neighbor and friend Henry Ford became regular visitors to Sanibel. In their search for new rubber sources, Edison and Ford would visit the island searching for exotic plants to take back to Edison's winter home and laboratory in Fort Myers, nestled on the banks of the Caloosahatchee River. It was Edison that made royal palm trees so popular in this area. He imported them directly from Cuba to line the street in front of his Fort Myers home.

Three of the cottages at the Sisters Hotel in 1908 are pictured above. The center cottage was where the Tayntor family stayed during their winter vacations. Mary Tayntor stands on the front porch. The road between the buildings clearly shows the markings of the cart used for transport around Sanibel. The Sisters Hotel later became known as the Casa Ybel Resort.

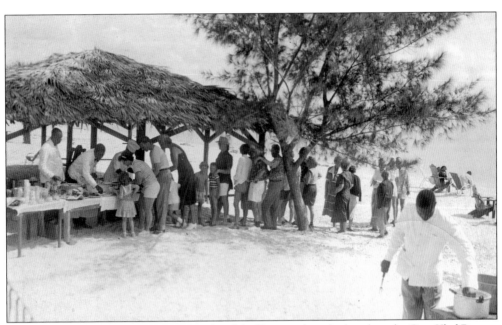

Friday afternoons during season meant a lunch buffet served on the beach at the Casa Ybel Resort. Behind the table on the left is Charlie Hurst and on the right cooking is Carl Jordan. Guests and other staff members in the photograph are unidentified. The Friday noon open buffets became a tradition at the resort until local health department regulations forced the resort to terminate the event. (Courtesy Island Inn.)

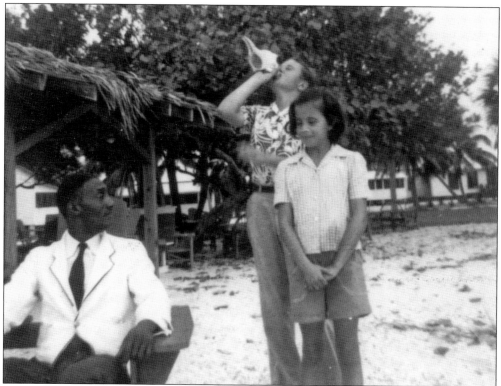

A custom at the Casa Ybel Resort was to call guests to dinner via the conch shell horn. An employee of the resort shares the custom with guests. From left to right are Ernest ?, Pete King, and Polly King. In the photograph below, a Gulf Airways plane uses the beach as an air-taxi landing site in the 1950s. The unidentified guest on the left and pilot Buddy Bobst, second from left, are assisted by Ernest, on the right, as they deplane on the beach at Casa Ybel. Flying in and landing on the beach was a common practice for winter residents of the resort for many years. (Courtesy Island Inn.)

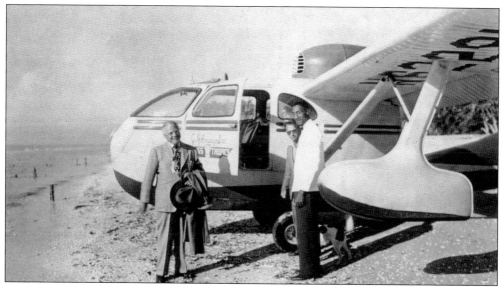

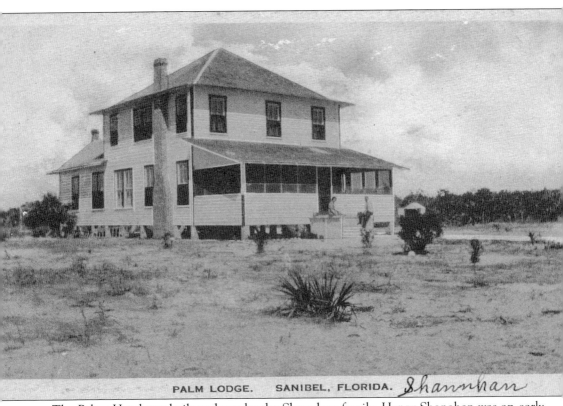

PALM LODGE. SANIBEL, FLORIDA. *Shannhan*

The Palms Hotel was built and run by the Shanahan family. Henry Shanahan was an early lighthouse keeper, and his sons and stepson also assisted in the lighthouse duties. Famous visitors to the hotel included poet Edna St. Vincent Millay and her husband, Eugene Boissevain. They visited the island and stayed at the hotel in the spring of 1936. The same day they arrived, the entire building caught fire and burned to the ground, destroying everything inside, including a handwritten play manuscript that Millay had just completed. She spent the next year reconstructing the manuscript. Plans were drawn up to rebuild the Palms Hotel after the fire, but construction never got underway. After the Shanahans lost the hotel to the fire, they converted a cottage on their property into their new residence. Eventually, they turned that into a seashell shop, and since it was located near the ferry landing by the lighthouse, this was an ideal tourist attraction at that time. The picture dates from between 1920 and 1935.

At right is a portrait of Laetitia Ashmore Nutt as a young belle around 1860. Nutt followed her husband, Confederate captain LeRoy Moncure Nutt, through a number of battles during the Civil War, and when he was captured, serving a year as a prisoner of war, she lived nearby. He later became a lawyer and Louisiana state senator before his death from yellow fever. The widowed Nutt was encouraged to move to Sanibel by her friend, Rev. George Barnes, because of the homesteading opportunities. Below is a c. 1890 photograph of Gray Gables, owned by the Nutt family. Laetitia Nutt arrived with her three daughters in 1889 and eventually opened the still-existing farmhouse. Nutt and her three daughters, Cordie, Lettie, and Nannie, were all well-respected schoolteachers. The Fort Myers chapter of the United Daughters of the Confederacy is named in her honor.

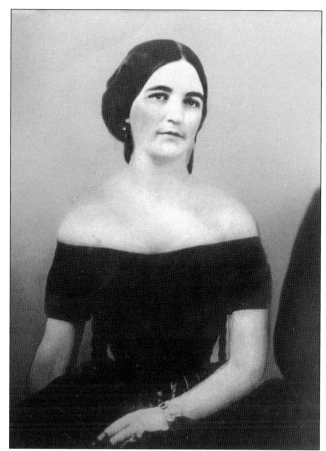

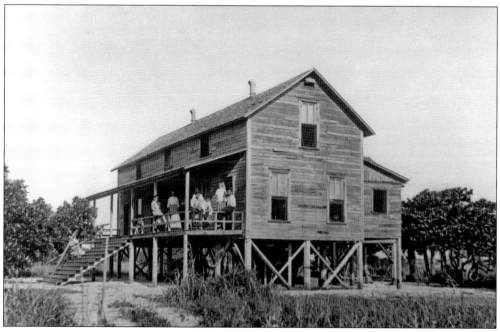

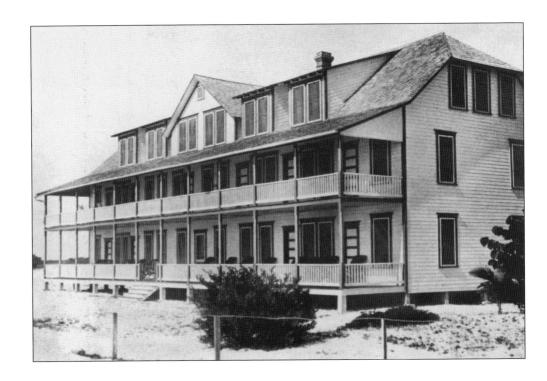

The Barracks at Island Inn, seen around 1917, was built to replace the original two-story guest lodge that burned in a nighttime fire in 1914. It was an imposing three-story, 30-room lodge with open porches at back and front that overlooked the beach and the gulf. It was owned and built by Harriet and Will Matthews, early pioneers that built a successful boardinghouse into the Island Inn Complex that has been in existence for over 100 years. (Courtesy Mary Irving collection.)

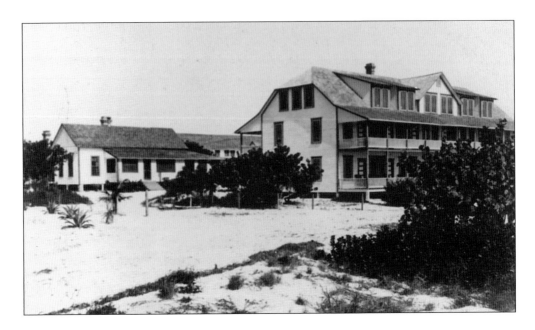

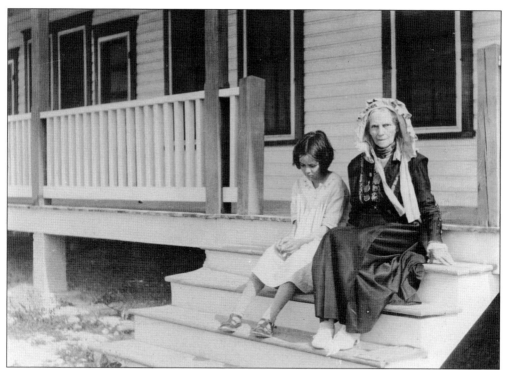

Carol Hemingway sits on the steps of the Barracks at the Matthews Hotel (now the Island Inn) on Sanibel with her grandmother Adelaide Hemingway in April 1921. Carol Hemingway stands on the Sanibel Gulf of Mexico beach with a young black girl in the photograph below, also taken in April 1921.

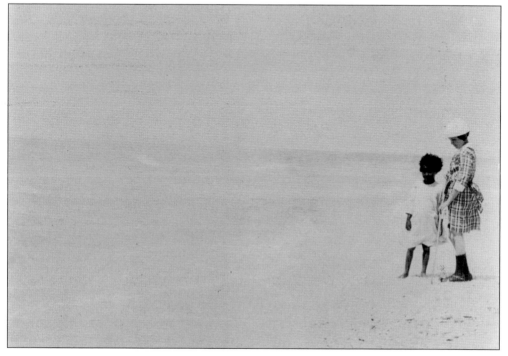

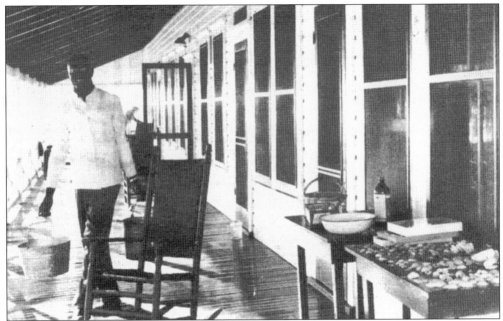

Roosevelt Preston first came to Sanibel in 1934. He was persuaded by a friend to work for one year at the Island Inn doing odd jobs. Mastering every job around the inn, his employment lasted 42 years. Preston's regal manner, commanding presence, and engaging personality made him a favorite among guests and staff. Whether chauffeuring guests, handling mechanical or plumbing problems, or covering the hotel in the absence of the owners, Preston was a reliable and efficient manager. He was a fixture at the Island Inn until his death in 1981. When Preston first started, it was still called the Matthews, pictured below, and was run by Hallie Matthews and her daughter Charlotta. In 1995, the Island Inn celebrated its centennial year. The inn has a historical record of over 100 years of continuous operation, surpassed by no other hotel on Sanibel. (Courtesy Island Inn.)

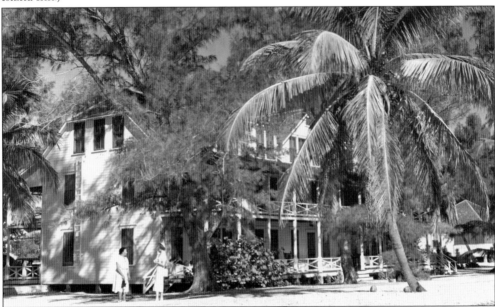

Irene Preston, pictured at right, arrived at the Island Inn on Sanibel in 1950 to join her husband, Roosevelt Preston. She began her career as a waitress and chambermaid on a seasonal basis. By the time she retired, 38 years later, she was the executive director of housekeeping. In 1963, Preston moved permanently into employee quarters at the Island Inn, where she raised her five children, Thelma, Laura, Matthews, Calvin, and Roosevelt Jr., as well as her four stepchildren, Louise, Roy, Roscoe, and Willie Frank. In the photograph below, taken in 1967, members of the Preston family stand in front of their new employee housing. (Courtesy Island Inn.)

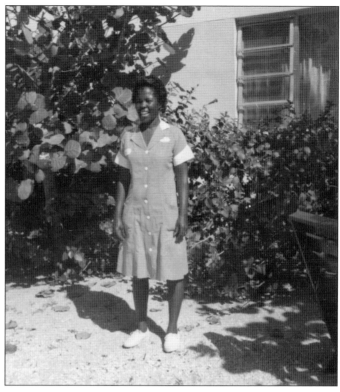

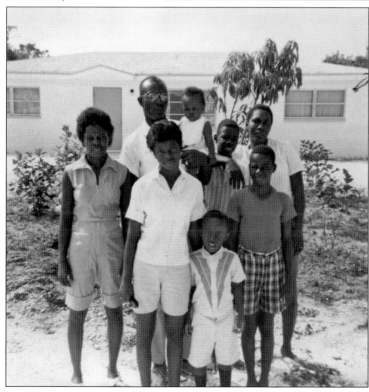

In the photograph at left, standing in front of the Island Inn are family members of the staff, Roosevelt Preston Jr. (left) and Jennifer Rushworth. Roosevelt Jr. was the son of longtime Island Inn employees Irene and Roosevelt Preston. Jennifer Rushworth was the third child of Jack and Milbrey Rushworth. The Rushworths managed the Island Inn from 1964 to 1990. They were instrumental in establishing new employee working conditions and general structural improvements to the complex. Children of employees grew up and played together, creating a family atmosphere at the inn. Below, unidentified children pose for a picture on the property. (Courtesy Island Inn.)

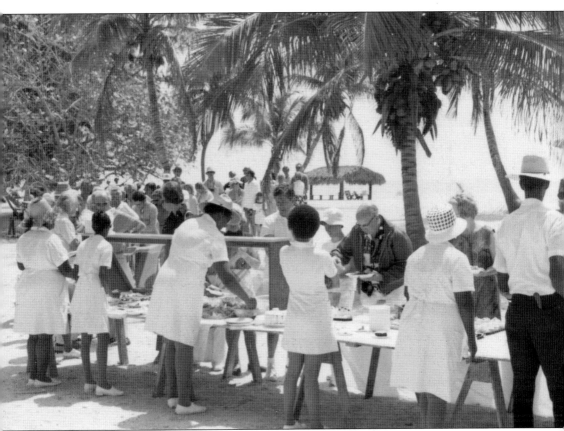

Dining room lunches at the Island Inn were phased out during the Rushworth's early management years, as new construction had placed kitchens and refrigerators in every room. The traditional social event of dining room lunches was substituted with outdoor buffets. Thursday-afternoon beach buffets became a tradition where food was served on long tables under twisted seagrape trees in front of the Island Inn overlooking the beauty of the gulf. This was a popular event, and the bountiful, delicious lunches appealed to the inn's guests and attracted a large following on the island. Popular island dishes were prepared and included in the weekly buffets, such as Chef James's mouth-watering chicken and seafood dishes, various exotic salads, and fresh tropical fruit. Local health department regulations soon mandated that the uncovered beach buffets be terminated, and the midday meal was then substituted with box lunches provided on request. (Courtesy Island Inn.)

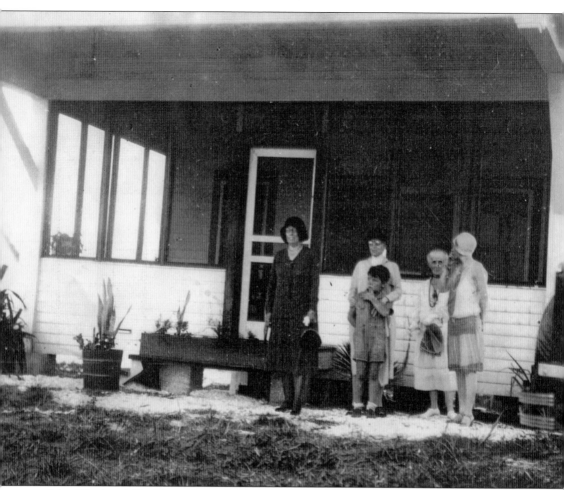

Miss Charlotta's Tea House, located on San Carlos Bay next to the Baileys' general store, was built in the early 1930s. It was originally built to serve as a gas station, but after the hurricane of 1926, it served as a temporary location for the Bailey general store. Charlotta Matthews, the sister-in-law of owner Frank Bailey, suggested that the building be used as a tea room serving ferry and store patrons. It soon became a cozy and comfortable location that visitors and travelers could enjoy while shopping or waiting for the ferry. Matthews was the daughter of Will and Harriet Matthews, longtime Sanibel innkeepers who founded the Matthews Hotel in the early 1900s. She did most of her cooking at the Matthews. She delivered her homemade pastries, soups, sandwiches, and beverages to the tearoom on a daily basis. From left to right are Kate Matthews, Mrs. Albert Willis, Sam Bailey, Hattie Matthews (Charlotta's mother), and Annie Mead Bailey.

The person at right is tentatively identified as Charlotta Matthews, seen in front of the Matthews Hotel, later known as the Island Inn, sometime between 1890 and 1910. Charlotta's parents started the Matthews Hotel in 1895 on a gulf-side Sanibel beach, and the hotel complex still operates today. She attended junior college in Ohio and after graduation returned to Sanibel to help her parents with bookkeeping and kitchen supervision at the inn. Matthews continued to run the hotel for many years after her parents retired. The photograph below depicts, on the left, early Sanibel settler Edmund Gavin and his daughter, Charlotta Gavin. Edmund Gavin worked as a laborer for Charlotta at the Matthews Hotel. In recognition of their mutual respect for each other, Gavin named his child after Matthews. (Courtesy Oscar Gavin.)

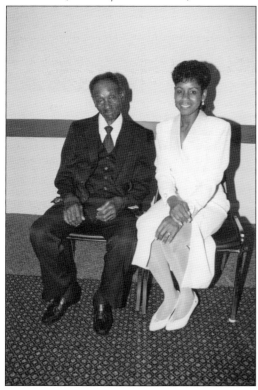

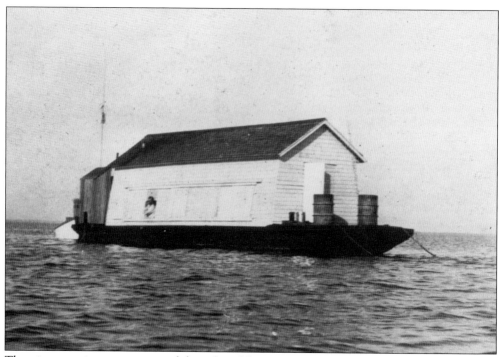

The winter tourist season attracted the rich and famous to Sanibel. The houseboat above, pictured c. 1914–1916, afforded Teddy Roosevelt privacy while vacationing on the islands. Roosevelt Channel, named in his honor, is located near Captiva, Sanibel's sister island. In the picture below stands the massive wooden Tarpon House around 1910, located to the left as one crosses the causeway, where condominiums stand today. This hotel, run by telegraph station operator George Schultz burned down in 1913. The telegraph station at Punta Rassa became famous as the first American spot to receive word of the sinking of the *Maine* on February 15, 1898, precipitating the Spanish-American War.

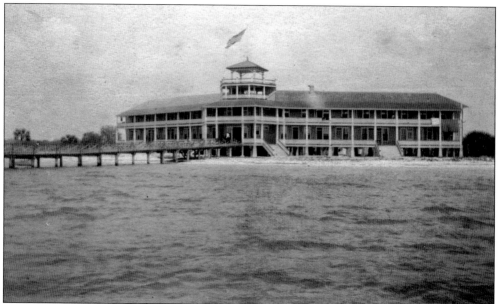

The first post office was established on Sanibel in 1894 and another one in the community of Wulfert in 1897. A special part of island living was going to the dock to wait for the mail boat. Lewis Doane, on the left surrounded by a number of unidentified neighbors, collects mailbags at the Wulfert dock. Jennie Doane, his wife, was Wulfert's postmistress and was considered to be an independent woman for her time. In the bottom photograph, Scotia Bryant sits on the steps of the tiny post office built by the Kinzie brothers near the ferry landing. Bryant became postmistress in 1943 and served in that capacity until 1967. When she began her career, there were only 75 year-round residents. After her retirement, the population had climbed so rapidly that the post office was moved to a larger Tarpon Bay Road location.

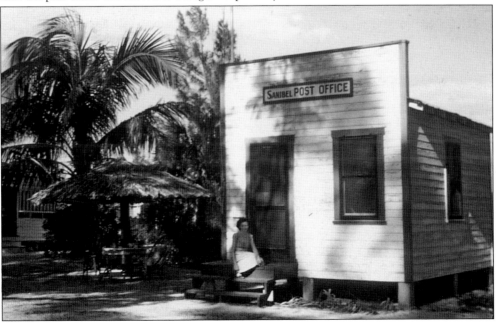

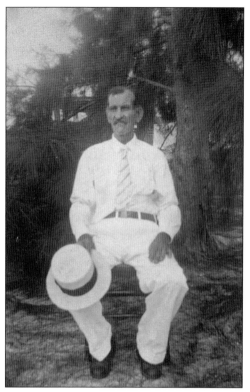

William S. Reed (left) was postmaster of the Sanibel Post Office by the lighthouse for 44 years. For two months, from December 1894 to February 1895, the postmark on the mail read Reed instead of Sanibel. Although the postmark was temporary, the Reed name was not. When Reed retired in 1940, one of his four daughters, Hazel Reed Godard, took over as postmistress. After the 1926 hurricane destroyed their home, Reed performed his postmaster's duties from the little building pictured below, which he constructed from salvaged lumber from that house. Reed, in addition to his postmaster duties, was also a census taker and an express agent responsible for labeling crates of vegetables for shipping.

The Bailey brothers (from left to right), Sam, Francis, and John, are shown above sitting on the deck of the ferryboat *Success*. Their father, Frank Bailey, moved here with his parents and two brothers, Ernest and Harry, in 1888 and took up farming. A farmer and merchant, Bailey took over the bayside dock and warehouse in 1899, quickly building a profitable business. He started the Sanibel Packing Company, which loaded island produce onto riverboat steamers. The packing company was the island's only general store, where islanders could buy farming equipment and household sundries and learn the local news. When Frank died in 1952, his sons, (below from left to right), Sam, Francis, and John, took over the family business. Now called Baileys' general store and in existence for over 100 years, the store is managed by Sam and Francis Bailey. (Courtesy Mary Irving collection.)

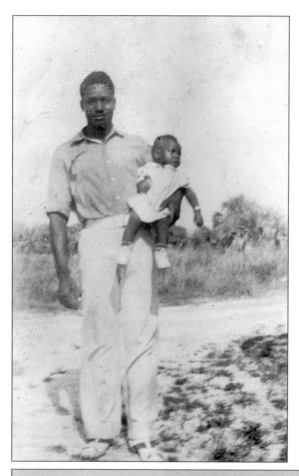

Pictured at left is Edmund Gavin, son of Isaiah and Hannah Gavin, early Sanibel pioneers. Gavin is standing with his first son, Edmund Jr., on one of the island's sparse roads. Gavin originally worked at the Island Inn. He left after a few years to start his own landscaping and construction business. He was a hardworking, well-respected island contractor. In 1984, he was acknowledged for his dedication to the community by being selected grand marshal of the Sanibel parade, commemorating the 10th birthday of the island's incorporation. As part of the festivities, Edmund rode in a Rolls Royce convertible at the head of the parade. (Courtesy Eugene Gavin.)

THE MARSHAL

Edmond Gavin

The noise and bustle of Saturday's grand parade will be a far cry for Edmond Gavin from the Sanibel he remembers more than a half century ago.

Living with his family in the solitude of the "Ding" Darling Wildlife Refuge for more than 50 years ago, Gavin, who will be the parade's grand marshal, got used to a simpler way of life than exists today.

Gavin misses the wildlife refuge he called home for 57 years. He was forced to move off the land in early 1975 because he and his family were "not compatible" with wildlife management practices, federal authorities said.

Today, the Gavins live on Rabbit Road — quite a change from the old life in the refuge. But Edmond says things haven't changed that much.

"I'm still doing a lot of fishing for mullet at the causeway, bird sanctuary and Tarpon Bay. But it ain't as good as it was when I was a boy," he says.

Gavin's wife Elnora likes the change that brought her family to Rabbit Road. "It's more ex-pensive than before, but it's better than living in Fort Myers. I never did like Fort Myers," she adds. The couple have 18 children.

Edmond Gavin is just glad he still can call Sanibel his home. "I don't worry about Ding Darling anymore, at least I'm going to die on Sanibel," Edmond adds.

As parade marshal, he will ride through Sanibel in a Rolls Royce convertible. □

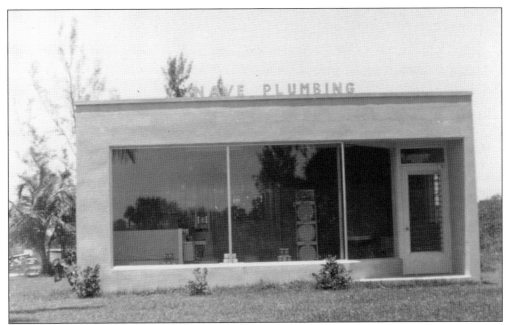

Nave Plumbing was established about 1951 by islanders Allen and Goldie Nave. Their original storefront was expanded to become a small complex on Periwinkle Way just east of the St. Michael's and All Angels Episcopal Church. Allen Nave first came to the islands before World War II and moved to Sanibel with his family in the late 1940s. Nave Plumbing continues to be a family-owned and -operated business, with Allen and Goldie at its head. An example of island plumbing and construction is shown in the picture below from April 1963, as the first blocks are laid in the reconstruction being done at the Island Inn, previously known as the Matthews Lodge. (Courtesy Island Inn.)

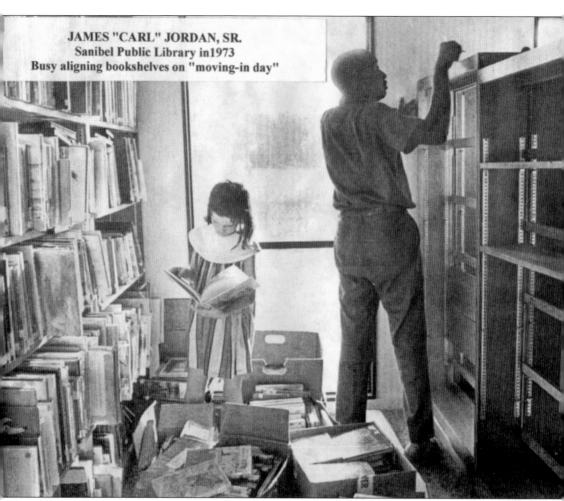

JAMES "CARL" JORDAN, SR.
Sanibel Public Library in 1973
Busy aligning bookshelves on "moving-in day"

In 1973, Carl Jordan is shown aligning bookshelves in the new Sanibel Public Library. On the left is Robin Pickens, a young helper. Jordan, a master carpenter and lifelong island resident, was in much demand for his services. He was known for his expertise in new construction, painting, electrical work, and carpentry. As Sanibel's population increased, the growth and expansion created a variety of jobs. There was always a demand for skilled laborers. (Courtesy Jordan family.)

Isaiah Gavin Jr., son of Isaiah and Hannah, is shown in a picture taken at the Gavin family reunion on Sanibel in 1996. Gavin served his country in World War II and years later moved back to this area. He worked in construction along with his father and brothers and did land clearing on many historic island projects, such as the Sears and Roebuck Shorehaven home. Gavin's father, Isaiah Sr., planted the Australian pine trees that once formed a lush canopy lining Sanibel's main thoroughfare, Periwinkle Way. The picture below, taken between 1950 and 1960, shows how Periwinkle appeared with the new vegetation. (Right, courtesy Eugene Gavin.)

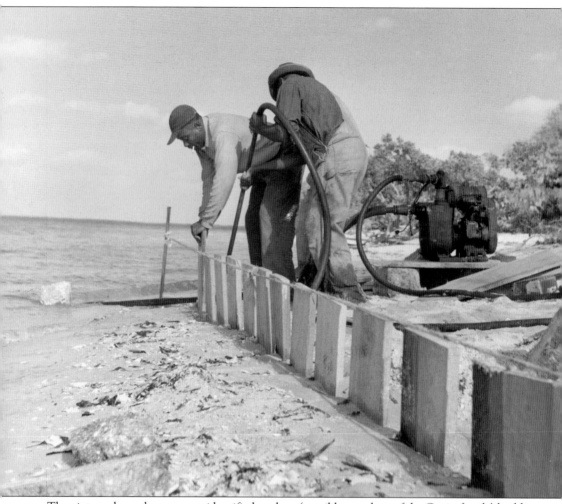

The picture above shows two unidentified workers (possibly members of the Gavin family) building what appears to be a seawall on the bay near Woodring Point. Seawalls were a common device used by landowners to prevent beach erosion on their property. (Courtesy Charles McCullough.)

Six

THE WINDS OF CHANGE

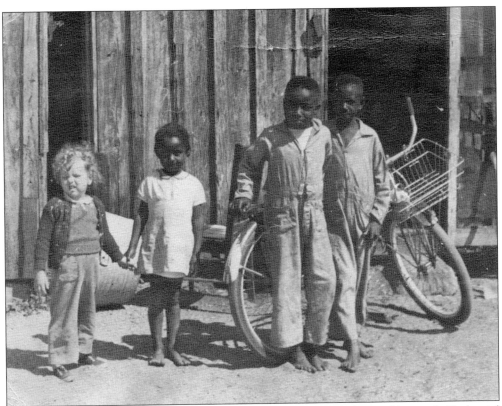

In picture above, from left to right, two unidentified girls, Carl Jordan, and his uncle Nathanial Walker stand in front of what appears to be a barn on Sanibel in the late 1930s. While white and black children played together on the island, they nonetheless were forced to attend separate schools. (Courtesy Jordan family.)

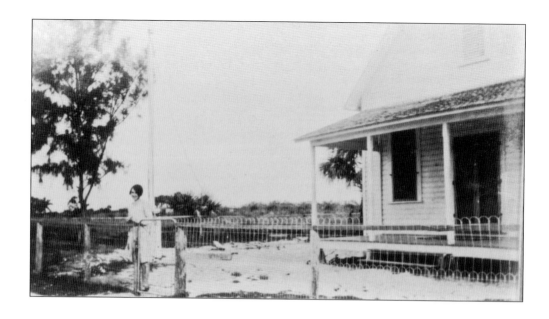

Pictured above are teacher Stella Belle Wilson in 1926 and the white schoolhouse that was her first teaching assignment at age 18. She had a total of nine students in various grades ranging from first to eighth. Below is the class of unidentified students standing in the fenced-in schoolyard in 1924.

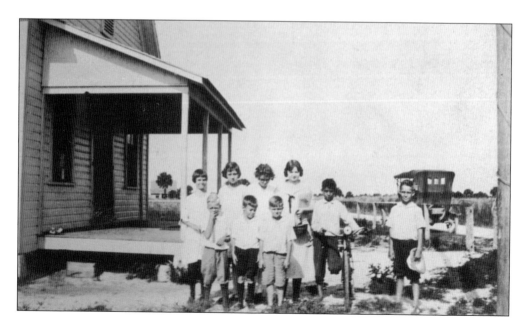

Jacob Johnson, a retired educator, was a young boy when he moved to Sanibel in 1924. His father, Isaac Johnson, was a sharecropper on the island who valued the importance of education. Johnson's father was instrumental in starting the first black school on Sanibel in 1927. The black school was located on Isaac Johnson's property on Island Inn Road and was an old Baptist church in 1917. In 1929, the building was purchased by the Lee County School Board. According to school board guidelines, a minimum of seven children had to be in attendance at all times. Occasionally there were not enough black children to keep the school open, so the students would have to commute to the mainland. The schoolhouse for black children on Sanibel did not resume until 1947, and then it only lasted four years before closing again. The building remained vacant, as seen in the photograph below, until 1968, when it became a commercial building. (Courtesy Lee County Black History Society, Inc.)

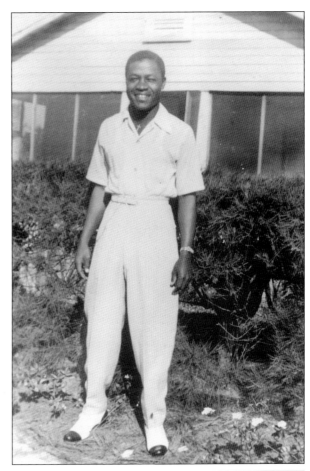

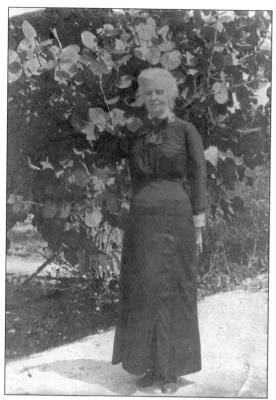

Cordelia Nutt (at left), called Miss Cordie, was one of the three Nutt sisters who homesteaded with their mother in 1889 on Sanibel. A teacher, she never married and is buried in the family graveyard at Gray Gables. The photograph of Miss Cordie was taken in 1922. One of the three daughters of Laetitia Nutt, who came to Sanibel to homestead in 1889, Letitia Lafon Nutt (below), called Miss Lettie by everyone, taught school in numerous southwest Florida locations. She never married and is buried in the family graveyard at Gray Gables, the home they built in 1889.

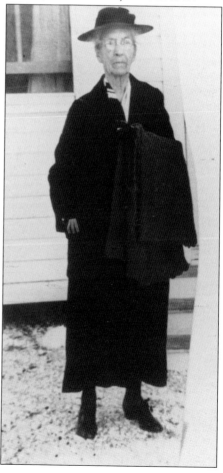

Harry Walker Jr., son of Pearl Alice and Harry Walker Sr., who arrived on Sanibel in the early 1920s, is pictured at right. Walker was the first family member to attend college and serve in the United States military. His influence carried on to subsequent generations, as the college degrees and graduates continue to this day. (Courtesy Eugene Gavin.)

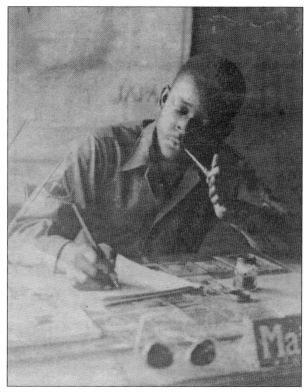

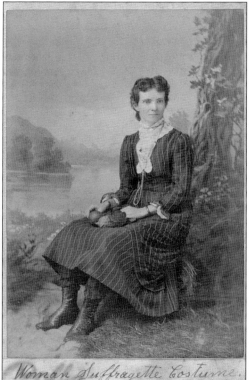

Jennie Doane of Wulfert is pictured, perhaps in the 1890s. Doane was an independent woman, a suffragette, and quite opinionated for her time. She became Wulfert's postmistress but failed to have the town of Wulfert named Doane after a dispute with another Wulfert family. A postal inspector, tired of the argument, arbitrarily named the place himself, and no one knows the name's origin.

Mattie Gavin married Oscar Gavin, the first black sanitation engineer on Sanibel. He started the first rubbish removal business on the island in the late 1950s. Mattie Gavin was a strong believer in civil rights. She was the first family member of her generation to obtain a voter registration card. To exercise her right to vote, Mattie had to first obtain proof of citizenship by securing census documentation, since birth certificates were generally not recorded for blacks during that time. She also made sure that other members of the family became registered voters by helping them with the time-consuming process. (Courtesy Eugene Gavin.)

Registration Certificate No. D-5032 Precinct No. 19
COUNTY OF LEE, STATE OF FLORIDA

Date Sept. 28, 1964

SEC. OF STATE

NAME Mattie Lee Gavin

Address 1935 High St. Ft. Myers

Age	Occupation	Col.	Sex	Party	Nativity	F. H.
53	Maid work	N	F	D	Fla.	Yes
Naturalization		Place		Date		Number

This Registration is made in accordance with the laws of the State of Florida.

Mattie Lee Gavin

Signature of Elector

Mrs. Clarence Chitz

By Barbara Smith

Supervisor of Registration **Deputy**

TOM ADAMS

110

Rev. George O. Barnes, on the left, and his wife, Jean, homesteaded on the island, as did their two daughters, Georgia and Marie, and son, William. Barnes discovered Sanibel by accident in 1889 when his sailboat hit a sandbar. He fell in love with the island and found that homesteading was available. Upon returning to his home state of Kentucky, he used his position as a minister to spread the word about this tropical paradise. Barnes persuaded many other Kentuckians to relocate to Sanibel, including the Matthewses, Nutts, and possibly relatives of the Gavins. He founded the Church of the Four Gospels, which he built in 1889. The church was designed with enough pews to accommodate 300 people, three times the island population.

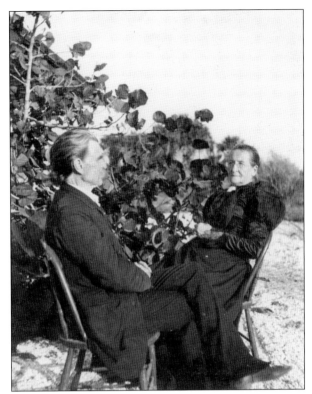

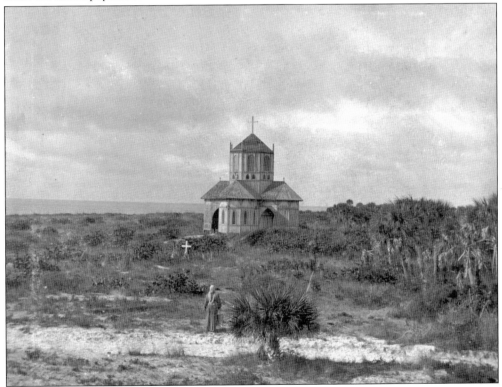

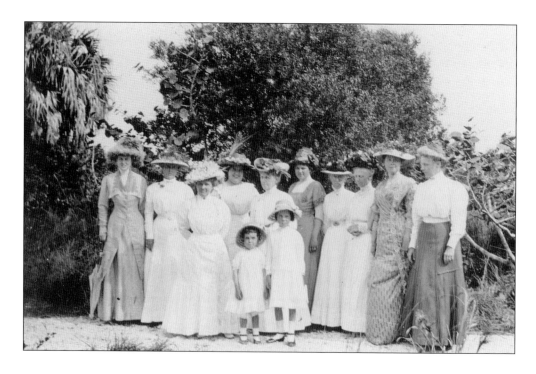

A group of unidentified women are shown in the photograph above visiting Sanibel in 1908. Perhaps, by the way they are dressed, they could be coming from Sunday church services being held at the Casa Ybel church or attending an afternoon brunch or social being held at the island lodge. In the photograph below, another group of women show off their fashionable attire at the Sisters Hotel, later called the Casa Ybel Resort, with several others mingling in the background at the popular Casa Ybel cottages. From left to right are Alice Tayntor, Mrs. Blaisdell, Marie Shulye, and Mary Tayntor around 1908.

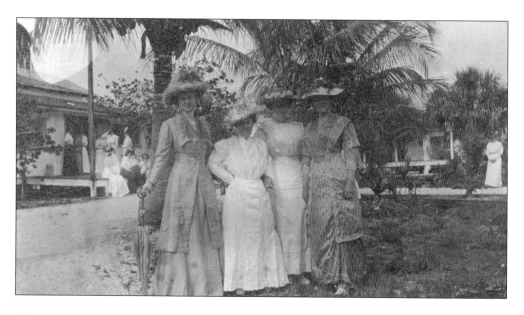

Pictured on the right is Fr. Thomas Madden of Saint Michael's and All Angels Episcopal Church, with an unidentified parishioner. Father Madden was a civil rights activist and was instrumental in integrating the church and the school on Sanibel. Below is Sunday school at Saint Michael's after integration, with members of the Gavin and Jordan families present on church property in the 1960s. (Right, courtesy Island Inn; below, courtesy Jordan family.)

Construction on Saint Michael's and All Angels Episcopal Church began in 1960 and was completed in 1961. Church was formerly held in the Casa Marina restaurant until Hurricane Donna ripped off its roof. After completion, Father Madden insisted that all were welcome to worship in his new church, blacks and whites alike. From that point on, the church and the Sunday school became integrated. Saint Michael's was the first church on Sanibel Island to become integrated. Black families no longer had to take the ferry to the mainland to worship. The pictures above and below are of the church during and after construction. (Courtesy Island Inn.)

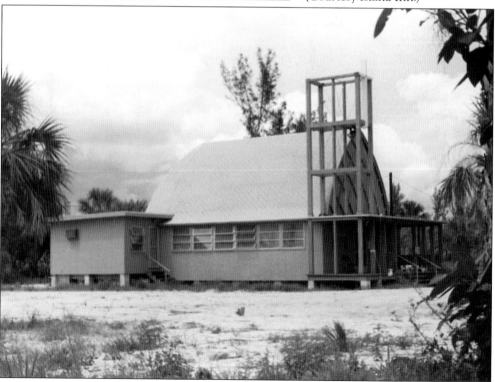

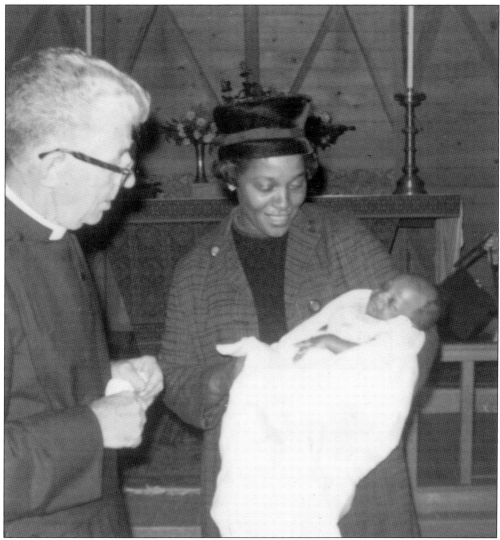

Father Madden is shown baptizing Tim Jordan, the first black child baptized on Sanibel Island in the 1960s. Tim was the son of James Carl Jordan and his wife, Mozella Belin Jordan. Jordan family members continue to worship at Saint Michael's to this day, and fourth- and fifth-generation Jordans have been baptized in this church. Carl Jordan, born in 1932, was the first black child born on Sanibel Island. These two historic events are just a part of the Jordan family legacy. Pictured from left to right are Fr. Thomas Madden, Mozella Jordan, and Timothy Jordan at the church ceremony. (Courtesy Jordan family.)

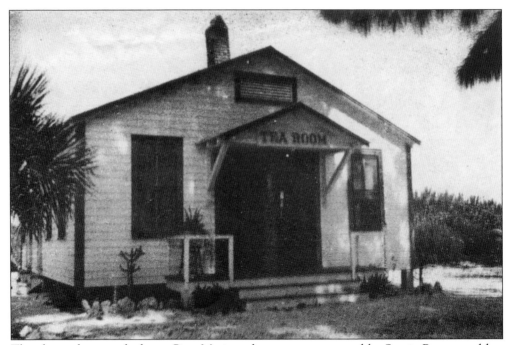

The above photograph shows Casa Marina, the tearoom operated by Scotia Bryant and her mother, as it appears in the 1940s. The building still stands, slightly modified, near Scotia's home at the lighthouse end of the island. The Casa Marina once served as a church before Hurricane Donna in the 1960s.

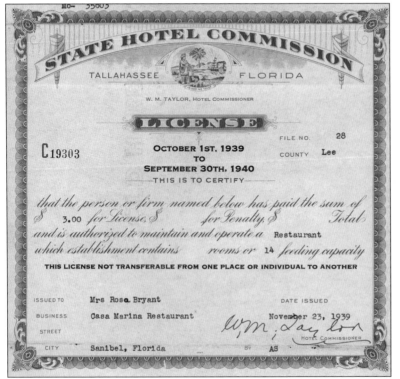

The picture on the left, dated November 1939, is a copy of the State Hotel Commission license to operate the Casa Marina restaurant and tearoom. In 1939, the Sanibel tearoom began servicing patrons waiting for the ferry, when the ferry landing was moved to the San Carlos Bay side of the island not far from the lighthouse.

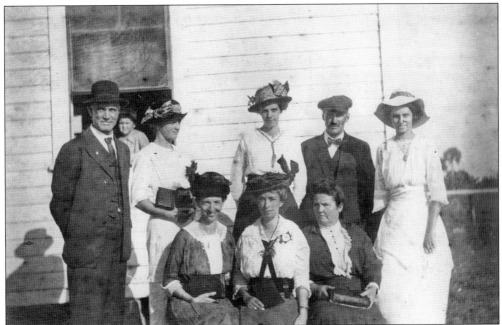

A Sunday school class held at the Sanibel School is pictured after 1910. In 1910, a hurricane destroyed the island's only church, and one was not reconstructed until about 1917, so services were held in other venues. Mrs. Page, the Sunday school teacher, is seated in the middle. Standing from left to right are Ernest Bailey, unidentified, Lois Swint Mitchell, unidentified, and Bertha Daniels. The Mitchell family donated land for the new church, constructed in 1917. Not only did they hold Sunday school at the church, but they also held many weddings. In the picture below at the wedding of Clara Graves, Lena Graves and Fred Collins pose for a photograph on September 3, 1903.

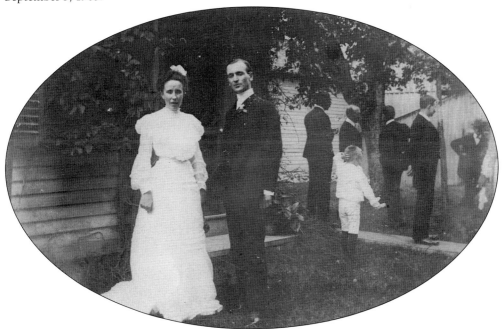

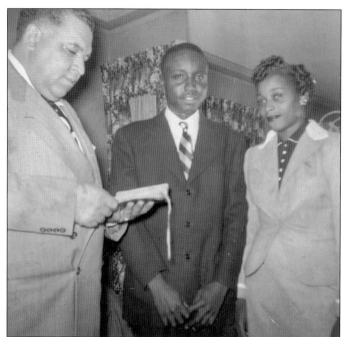

Carl Jordan and Mozella Belin, on their wedding day in 1950, are shown reading their vows with their pastor. Carl died in May 2000, and Mozella died in May 2007. They are buried next to each other in a local cemetery on the mainland. (Courtesy Jordan family.)

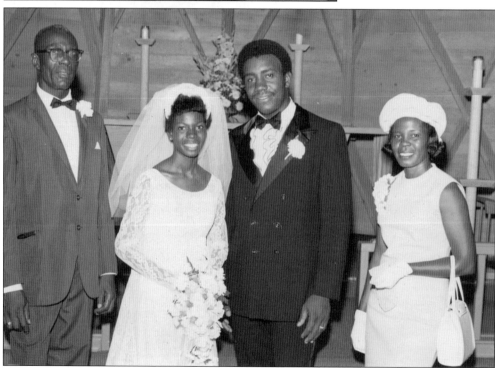

This picture depicts the wedding of Oscar Gavin and Laura Preston. In attendance on the left is her father, Roosevelt Preston, and on her right is her mother, Irene Preston. The ceremony was held at the Island Inn. Gavin is the son of Edmund and Elnora Gavin, early Sanibel pioneers. Laura's parents, Roosevelt and Irene, were longtime and much respected Island Inn employees. (Courtesy Island Inn.)

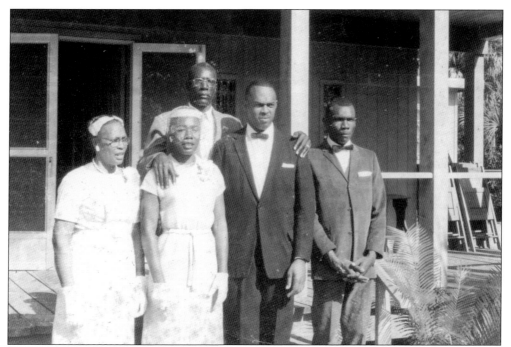

Parishioners are shown in the picture above after Sunday church services at the Island Inn in 1967. Church services for black families were often held at informal locations on the island, even outside on the causeway. From left to right are Queenie Hurst, Louise Preston, Roosevelt Preston, Calvin Preston, and Roscoe Preston. (Courtesy Island Inn.)

This photograph taken around 1973 is an angled view of the Sanibel Community Church, built in 1917. The nondenominational church was the only one on Sanibel for many years. Sanibel's first church, built on the Gulf of Mexico at the present Casa Ybel Resort, was destroyed in the 1910 hurricane. Pews and some stained glass from that church were reinstalled in this building when it was constructed.

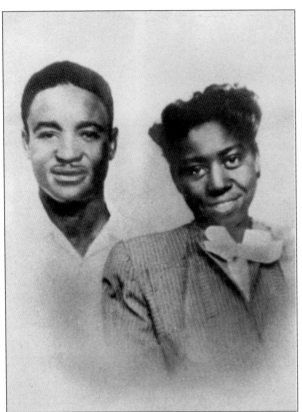

Elnora Walker and Edmund Gavin are shown on their wedding day in 1933. Both families settled on Sanibel between 1917 and 1920. This marriage united the Gavins and the Walkers, two early pioneering black families. Elnora was a most beloved and admired island women for many years until her death on January 6, 1991. Edmund followed her in death a few years later. (Courtesy Eugene Gavin.)

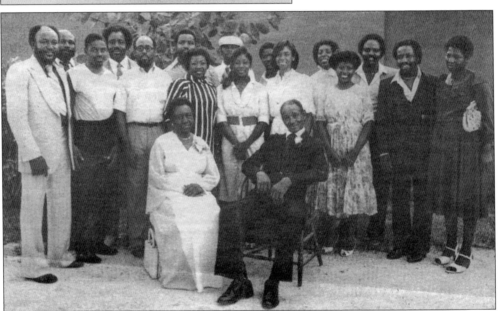

Elnora and Edmund Gavin are surrounded by their children at a 1984 family reunion. The Gavins lived on the Sanibel for over 60 years. They raised 20 children on the island, and many of their offspring still live here today. For this family reunion, over 200 family members from 14 states traveled to Sanibel to return to their roots. (Courtesy Oscar Gavin.)

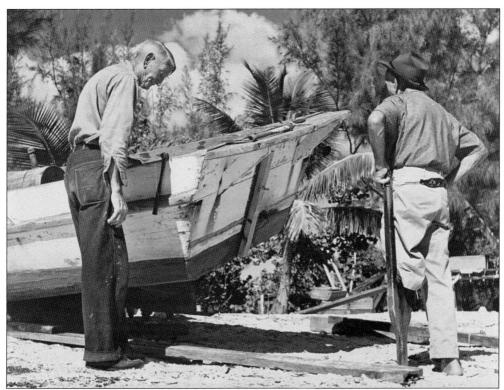

In the above picture, John "Pegleg" Dugan and Eldon "Dad" White are shown on Woodring Point. After the hurricane of 1944, Pegleg was assumed dead because his wooden leg was found on the beach. The next day, much to everyone's joy, he managed to disentangle himself from the mangroves and find his way to safety.

An unidentified woman in the photograph above is comforting a whitetail deer discovered after the hurricane of 1910. Deer roamed the island in significant numbers during the early days. Farmers often had to pick, pack, and ship their produce in a hurry to prevent the crops from being decimated by the wildlife. After the hurricane of 1910, a lone deer was seen at the lighthouse. To this day, it remains the last sighting of a deer on the island.

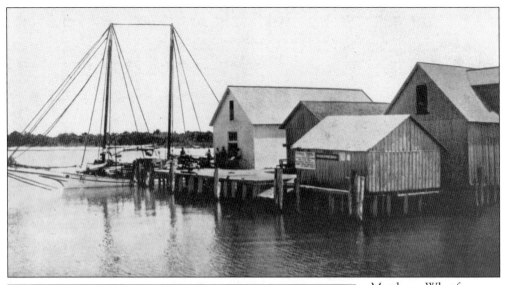

Matthews Wharf, pictured above, was destroyed after the hurricane of 1926, along with the Sanibel Packing House and the Kinzie Ferry Dock. In the picture at left, a Kinzie Brothers ferry is show overturned after Hurricane Donna in 1960. Hurricane season is officially June through November. However, every hurricane that has hit Sanibel during the last 100 years has arrived in either September or October: October 17, 1910; October 25, 1921; September 19, 1926; September 3, 1935; October 18, 1944; September 17, 1947; and September 10, 1960. The most recent storm, Hurricane Charlie, was an exception, hitting Sanibel in August 2004. (Above, courtesy Mary Irving collection.)

Although the bomb shelter received little or no use, it was a good possible hurricane shelter in an emergency. The structure was built during World War II. At the time, there were less than 100 residents living on the island. However, things were far from quiet. Enemy submarines patrolled the surrounding waters, and a spotting tower was erected at the lighthouse. Military pilots and bombardiers were trained over island beaches, and a Coast Guard detachment was stationed at the Casa Ybel Resort.

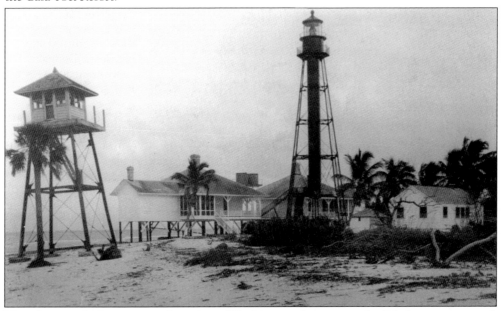

This photograph shows a view from the gulf looking northwest over the lighthouse compound, with pilings from the Gulfside Wharf still remaining. By 1946, these were almost all gone. A submarine observation tower on the left and quarters built during World War II are shown. The pump house and the cistern for the western quarters still exist in this picture, so the photograph was taken before the 1944 storm, when wind gusts reached 100 miles per hour, blowing in straight north from Cuba. Fishing boats were lost at sea trying to make it back to Sanibel.

An unidentified black lady stands by a car in the picture above. She may have been a visitor or one of the many service people hired to work at island resorts during the tourist season. Sanibel has approximately 6,000 year-round residents, but during the season, that number swells to over 35,000. Service employees and domestics provide the much-needed assistance to handle this annual influx. (Courtesy Captiva Public Library.)

In the picture above, a mule-drawn wagon driven by an unidentified black male (possibly a member of the Gavin family) passes a car on a dirt road. This picture is symbolic of the old meeting new on Sanibel Island and the challenges of maintaining a healthy balance so as to preserve the island's unique history and flavor.

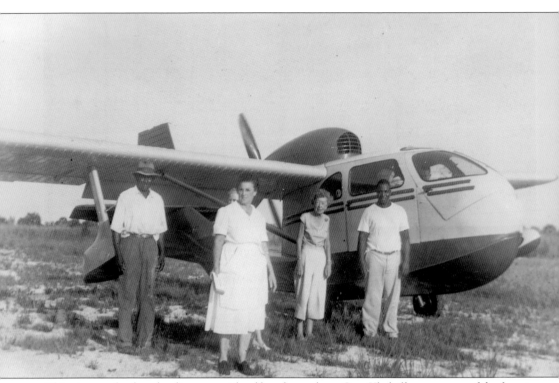

This picture of a plane landing on an island beach, maybe at Casa Ybel, illustrates one of the favorite ways visitors came to Sanibel before the causeway. After the causeway, visitors mainly traveled onto the island by car instead of by commuter plane or ferry. The opening of the causeway in 1963 brought many changes to the island, some good and some not so good. (Courtesy Island Inn.)

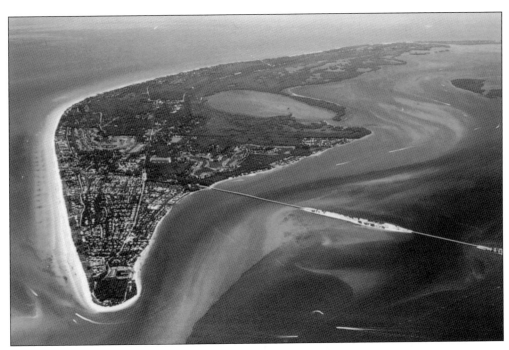

The aerial view of the causeway above and the causeway tollbooth below represent a changing way of life on Sanibel Island. Many people were saddened to see the ferry service that connected the island to the mainland come to an end in 1963. Progress and change are inevitable, even for a barrier island like Sanibel. In October 2007, the original causeway and drawbridge were demolished, and a new span connecting the island to the outside world was constructed. The tollbooth continues to be the gateway on and off this island paradise. (Above, courtesy Charles McCullough.)

Discover Thousands of Local History Books Featuring Millions of Vintage Images

Arcadia Publishing, the leading local history publisher in the United States, is committed to making history accessible and meaningful through publishing books that celebrate and preserve the heritage of America's people and places.

Find more books like this at
www.arcadiapublishing.com

Search for your hometown history, your old stomping grounds, and even your favorite sports team.

Consistent with our mission to preserve history on a local level, this book was printed in South Carolina on American-made paper and manufactured entirely in the United States. Products carrying the accredited Forest Stewardship Council (FSC) label are printed on 100 percent FSC-certified paper.

MADE IN THE